IMAGES
of America

LOST
HARTFORD

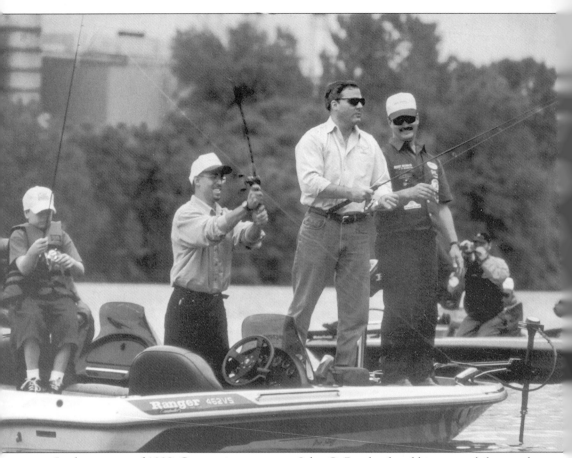

In the summer of 1998, Connecticut governor John G. Rowland and his son, at left, went bass fishing on the Connecticut River. They were accompanied by George Colon, second from the left, a Hartford Public High School student. Colon gained national attention by focusing on fishing as a means of attaining positive goals, instead of being involved in drugs and gangs. The made-for-television professional bass tournament brought the biggest names in the fishing world to Hartford's riverfront to compete for the $1 million in prizes. It is precisely this kind of high-profile event, supported by the governor and other leaders, that has made recapturing access to the Connecticut River a reality. (RRI.)

IMAGES
of America

LOST
HARTFORD

Wilson H. Faude

ARCADIA

Copyright © 2000 by Wilson H. Faude.
ISBN 0-7385-0463-7

First printed in 2000.

Published by Arcadia Publishing,
an imprint of Tempus Publishing, Inc.
2 Cumberland Street
Charleston, SC 29401

Printed in Great Britain.

Library of Congress Catalog Card Number: Applied for.

For all general information contact Arcadia Publishing at:
Telephone 843-853-2070
Fax 843-853-0044
E-Mail sales@arcadiapublishing.com

For customer service and orders:
Toll-Free 1-888-313-2665

Visit us on the internet at http://www.arcadiapublishing.com

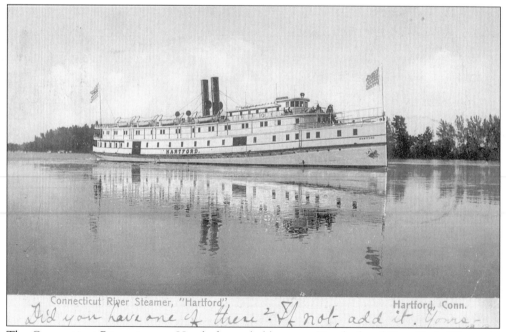

The Connecticut River steamer *Hartford* traveled between Hartford and New York. The main steamboat dock was at the foot of State Street. Many people remember getting on the boat on a Friday night after work and waking up in New York. Regular riverboat service stopped in 1931. (Old State House.)

CONTENTS

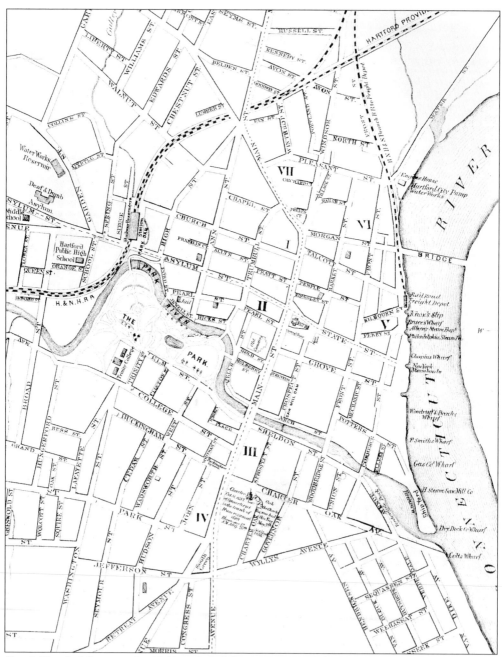

Geer's *Hartford Directory* for 1869 included this "new map of the city of Hartford from the latest surveys." The Connecticut River is on the right. Note all the wharves and slips that are shown. For more than 200 years, Hartford was a major port. The Old State House is at the top of State Street. Trinity College is in Bushnell Park, and the Park River flows freely through the park.(Old State House.)

INTRODUCTION

This is the golden age of Hartford. Forget what all the naysayers claim; this is the best time to be in Hartford. There is so much happening. There are so many plans. When we take stock of what is no longer here, we must also take stock of what is here and of the leadership and commitment and the great institutions that are here. So, I hope all will read this with two minds: one to learn from the lessons of the past and two to shamelessly enjoy the great riches that are here. It is time to shed our mantle of "We can't" and instead say, "What if," "Let's do it," and "Here we go."

Cities change, evolve, and change some more. Change brings a vibrancy to a city. The Connecticut River is a prime example of this evolution and of people's ability to dream and to fulfill those dreams. The river has gone from a highway of commerce to a flooding menace to something to cross over to an asset to be recaptured. Change, renewal, new ideas, restoration, revitalization, new hopes, and dreams should be the life for a city.

This book is for my wife, Janet, and for our two great children, Sarah and Paul.

This book is for one a loyal friend and wise counselor, the incomparable Jo McKenzie.

This book is for a mentor, friend, and colleague, William R. Peelle.

This book is for one who dared to dream for St. Monica's, the Hartford Public Schools, and the Old State House, Edythe Gaines.

And this book is for George Kearns of the Natural, one of Hartford's finest eateries, who has graciously fed the Old State House's special guests.

This book is for all who care about Hartford—past, present, and future.

Books like this are possible only when the photographs are shared. After each photograph is listed the source of the photograph. If you would like a print, either write to the Old State House or contact the source directly. I am especially indebted to Ken Wiggins, state librarian, and Mark Jones, archivist, Connecticut State Library, for allowing the use of the Samuel Taylor Collection. Taylor (1833–1908) photographed his changing city. His daughters added to the collection in the years 1910 to 1915. The Connecticut State Library and the Old State House will share the profits from this book. I am also grateful to the other lenders: Aetna, the Bushnell, the Connecticut Department of Transportation (DOT), the Hartford Public Library's Hartford Collection, Hartford Stage, Kula Professional Photofinishing Laboratories, Stewart Lewis, Bryant Miller, Moser Pilon Nelson Architects, Riverfront Recapture Incorporated (RRI), Trinity College, and the Wadsworth Atheneum.

Let the photographs and the memories begin.

Donn Barber's 1919 Travelers Tower, Benjamin Wistar Morris's 1920 Hartford Connecticut Trust building at 750 Main Street, Charles Bulfinch's 1796 Old State House, and the 1919 G. Fox building filled the Hartford skyline in the 1920s. This view is from the East Hartford side. The 1944 dike has not been built, and the post office behind the Old State House that was razed in 1934 is still standing. Note the radio towers of WTIC to the right of the Travelers Tower. WTIC's call letters are the initials of the station's first owner, the Travelers Insurance Company. (Kula No. 308.)

One

THE CONNECTICUT RIVER

Hartford was settled by the Native Americans, the Dutch, and the English because of the Connecticut River. The word Connecticut means "great tidal river," and the river is tidal from Long Island Sound to Windsor. In the beginning, it was the commercial highway that made Hartford a very busy port. Because of the commercial successes, Hartford developed as a banking and insurance center. In time the railroad and the car replaced the ship. The river then was used for industrial discharge. It was viewed as a menace when it flooded and destroyed property. It was to be contained. That is why the dike was built. The river was viewed as an obstacle to be crossed over. That is why the bridges—Bulkeley, Founders, as well as the Coffin, Bissell, and Charter Oak—were built. Finally the river became an asset to be recaptured. Here is part of the story of the river and the heroic efforts to recapture it.

Just north of State Street on the bank of the Connecticut River stood the River House. Formally known as the Ferry Street Hotel, it was managed by Calvin Spears. It was the place for passengers and riverboat men to stay. (Connecticut State Library, Taylor Collection No. 221.)

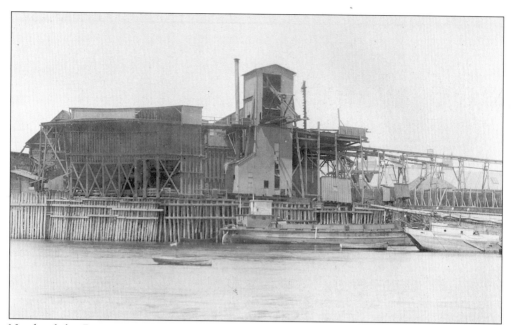

North of the River House off Kilbourn Street were the coal yards of Mason & Company, formerly Poole & Company. The coal was brought up the river on one of the barges or packets shown here. The coal was unloaded and stored in the warehouse behind the boat. In 1908, as part of the building of Bulkeley Bridge, this coal yard was demolished and replaced by the Connecticut Boulevard. (Connecticut State Library, Taylor Collection No. 218.)

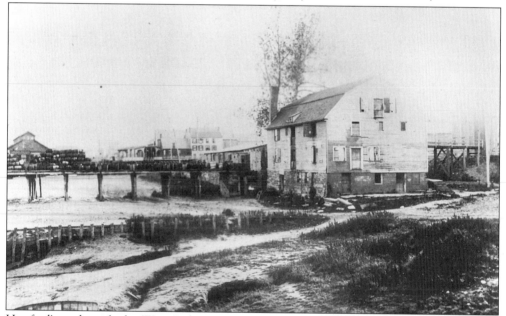

Hartford's trade with the West Indies was one of its most profitable. Shown is of one of the West India Trade storehouses near the Hartford riverfront. Beside the warehouse is an elevated wharf. It was elevated so that the barrels would be at the right height to load them easily on and off the ships. The number of barrels on the wharf is a statement of how busy the port was. (Connecticut State Library, Taylor Collection No.

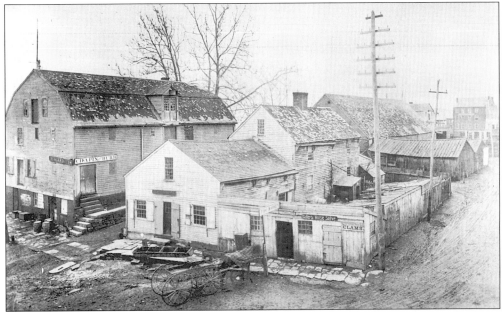

On Ferry Street was the Chapin & Burr storehouse, and to the right was Sam Church's store. The signs on the store say that it sold everything from clams to Daley's Horse Salve. Chapin's wharf and the river were just to the left of the Chapin building. (Connecticut State Library, Taylor Collection No. 224.)

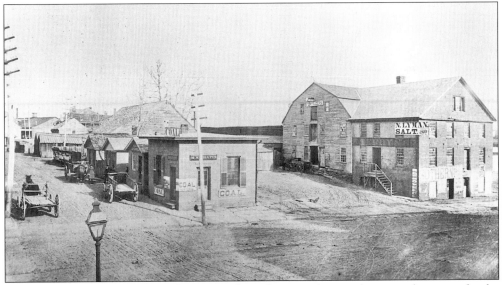

At the foot of State Street were the principal warehouse and stores that were the center for the commercial trade. The building that was formerly the Terry warehouse, on the right, has become N. Lyman, and its principle offering is salt. Chapin, on the corner, is advertising coal. (Connecticut State Library, Taylor Collection No. 228.)

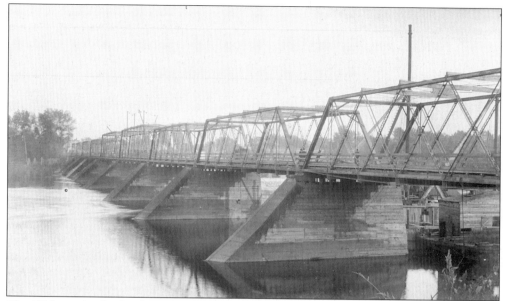

The 1818 wooden bridge that connected East Hartford and Hartford burned in 1895. There was much discussion and even more inaction. This temporary bridge was agreed to in 1900. Finally in 1902, the city voted to build a new permanent bridge. The bridge, known today as the Bulkeley Bridge, opened in grand ceremonies on October 6, 1908. (Snow Collection Old State House.)

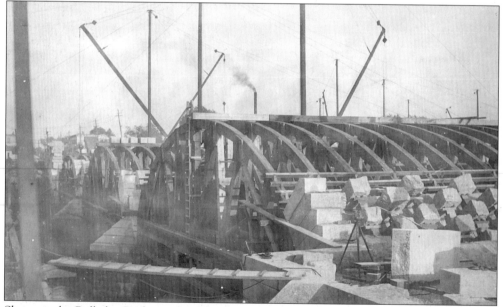

Shown is the Bulkeley Bridge under construction in the summer of 1905. It is the largest stone arched bridge in the world. It is named for Connecticut's governor and senator Morgan G. Bulkeley. Bulkeley was also president of Aetna, mayor of Hartford, and the first president of baseball's National League. (Snow Collection Old State House.)

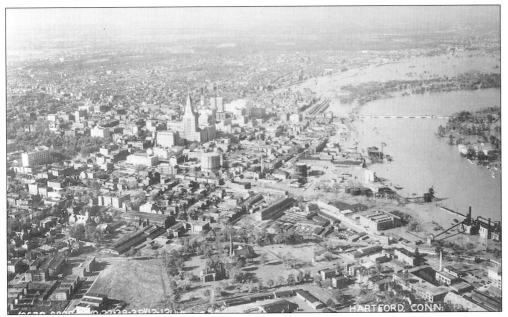

The 1938 hurricane and the resulting floods devastated Hartford. These pictures, taken on September 23, 1938, show the extent of the flooding. Above, the Bulkeley Bridge is nearly underwater. Everything below Market and Prospect Streets was underwater. Below, the freight yards on the left and the entrance to the Bulkeley Bridge were submerged. East Hartford's losses were astronomical, as can be seen at the top of the photograph. (Kula.)

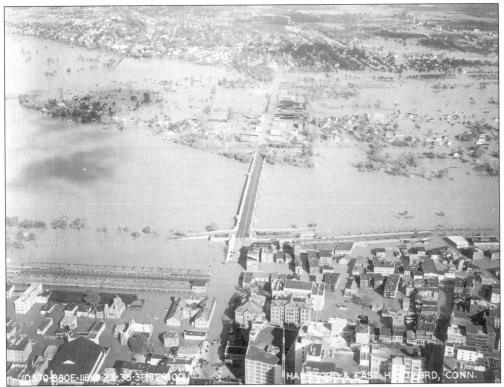

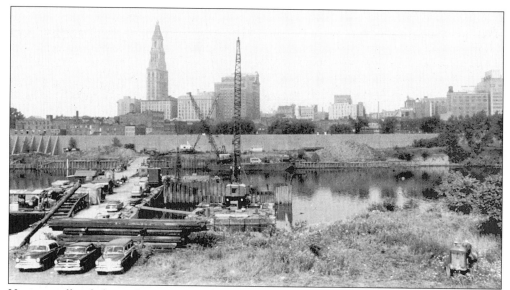

Having suffered from the 1936 floods and then the 1938 hurricane and floods, it was understandable that the business leaders said, "Enough!" The river was no longer the highway of commerce; it was something to cross over. The answer in 1942 was to build two dikes, one on each side of the river. Shown is the construction of the dike on the East Hartford side. The Hartford side appears done. (RRI.)

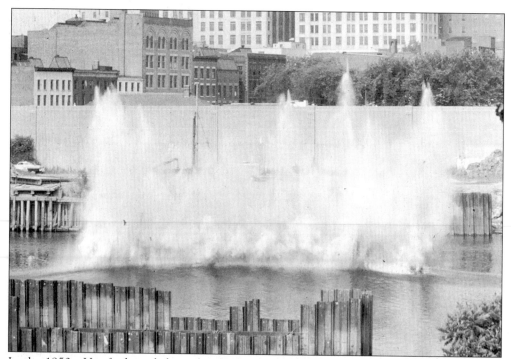

In the 1950s, Hartford needed another bridge to cross the Connecticut River. Shown is the blasting of the river bottom for the footings of what became the Founders Bridge. It was a toll bridge, and it opened in 1958. Visible behind the blasts are the wall of the dike and the buildings on State Street. (RRI.)

The first visible improvement to the Connecticut riverscape was the new dock at Charter Oak Landing. It meant that for the first time in more than 45 years, boats could dock in Hartford. Shown in the spring of 1985 is the dock, with the columns of the gazebo. The gazebo awaits its roof. (RRI.)

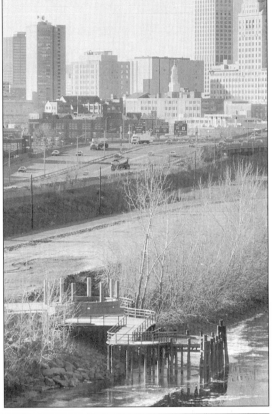

In the summer of 1989, Charter Oak Landing, a new park on Hartford's Riverfront, opened to the public. Gov. William A. O'Neill, center, was one of the project's visionary supporters. At the opening festivities, Riverfront Recapture board members Carole P. Bailey and Tim Moynihan, left, and Denise Nappier, executive director of Riverfront Recapture, right, escorted O'Neill. (RRI.)

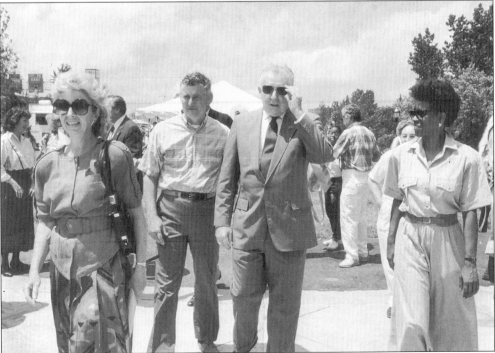

15

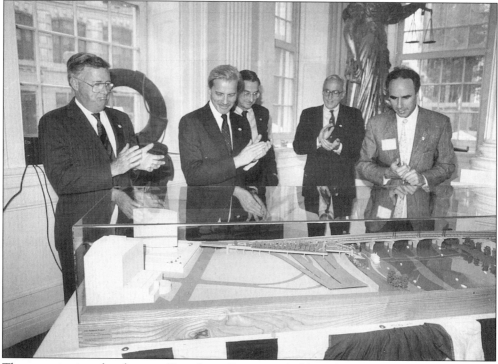

The organization that became Riverfront Recapture held its first meeting in the Old State House in the spring of 1981. For its tenth anniversary, the organization returned and unveiled the visionary plans for recapturing the Hartford riverfront: connecting Hartford and East Hartford with a pedestrian walkway, lowering Interstate 91, building a new Founders Bridge, and expanding the park system on both riverbanks. Applauding the model are those who later dedicated themselves to seeing that the plans became a reality. They are, from left to right, Connecticut Department of Transportation officials J. William Burns (former commissioner), and Emil H. Frankel (commissioner), and Riverfront Recapture officials John H. Riege (president), C. Roderick O'Neil (chairman), and Tyler Smith (chairman of planning).

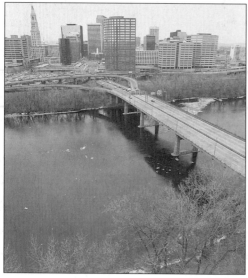

This view shows the Founders Bridge and Hartford as it looked in February 1992. The work that will transform the access to the river is about to begin. Led by the nonprofit group Riverfront Recapture, the transformation involves an extraordinary series of accomplishments. Compare this picture with the one on page 25. (RRI.)

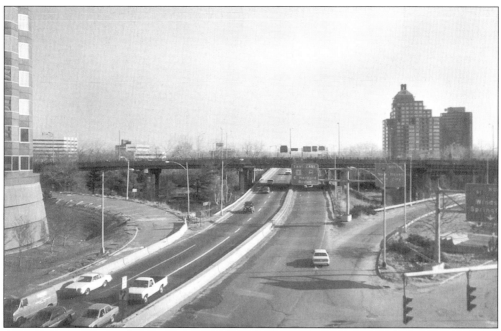

On January 7, 1992, this picture was taken from Constitution Plaza, looking east to the Founders Bridge. Note how the elevated Interstate 91 blocked the horizon. The plan called for lowering the highway beneath the Founders Bridge—without suspending service. (DOT.)

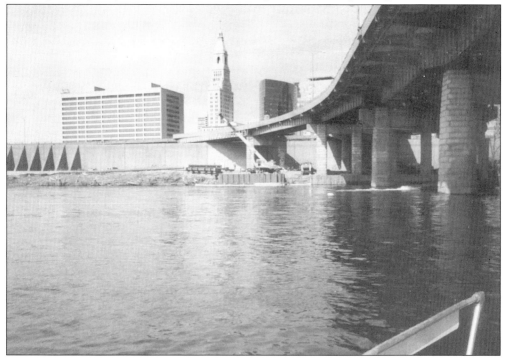

This view from the construction barge in the Connecticut River looks toward Hartford. The crew is working to remove one of the entrance ramps to the Founders Bridge. One can appreciate the height of the 1944 dike. The picture was taken on April 16, 1992. (DOT.)

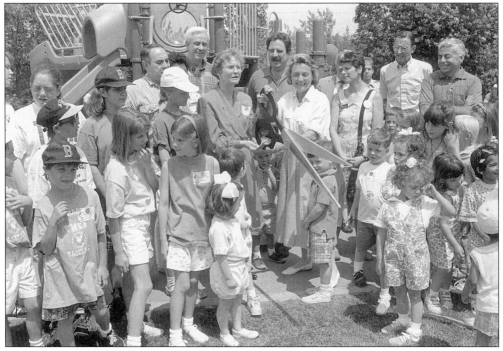

In the summer of 1992, Rep. Barbara B. Kennelly cut the ribbon to dedicate the new children's playscape at Charter Oak Landing. The Junior League of Hartford funded the playscape. (RRI.)

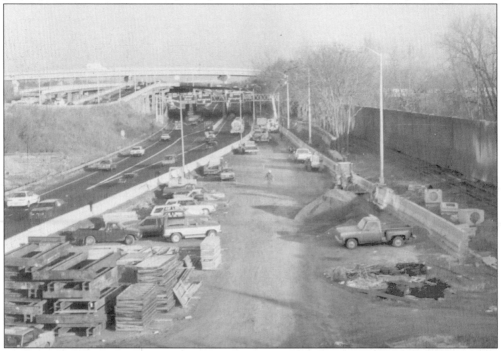

This view was taken on November 19, 1992, looking north from the Founders Bridge. The Hartford dike is on the right. Work has begun on Ramp C and on the new parapet wall for the relocated Interstate 91. (DOT.)

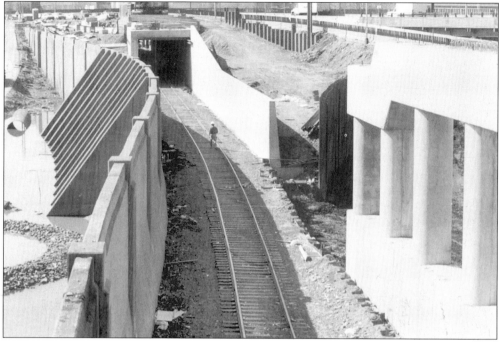

Careful planning for the project was dictated by the need to keep Interstate 91 and the railroad open, retain the massive dike, and build the piers for the new riverfront landing. This picture, taken on April 19, 1993, shares the close relationship of the dike, left, the rail line, center, and the new piers and the interstate, right (DOT.)

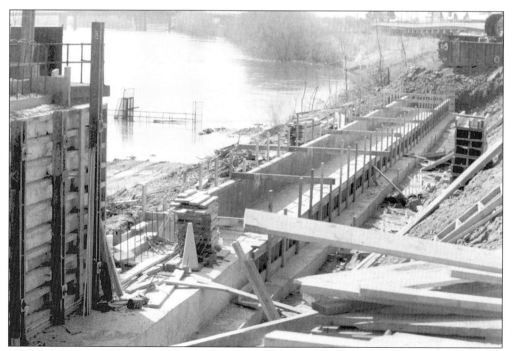

The footings for Wall 125 were poured on April 19, 1993. Beyond is the Connecticut River. (DOT.)

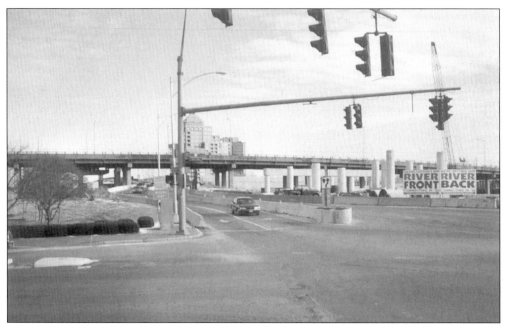

Years of planning finally produced visible results. In this December 28, 1993 photograph, the new piers for the landing emerge at the foot of State Street. Interstate 91 is still elevated over the Founders Bridge. Riverfront Recapture's sign, "River Front, River Back," advertises the good things to come (DOT.)

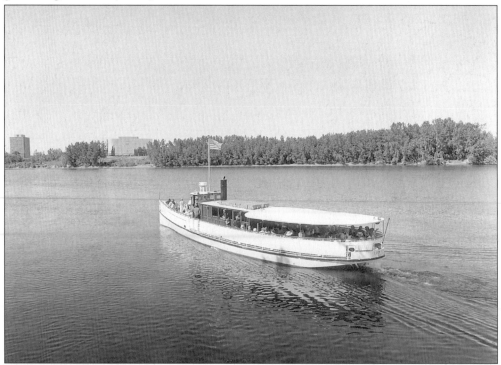

The new Charter Oak Landing made it possible for boats to again dock in Hartford. The *Lady Fenwick* and the *Becky Thatcher* provide river excursions.(RRI.)

Like many nonprofit organizations, Riverfront Recapture had to raise large sums to support the visionary plans. Cruises raised money and shared with the patrons the breathtaking beauty of the Connecticut River. Shown at a 1994 fund-raiser is East Hartford mayor Robert DeCrescenzo, left. On the right are board members Barbara Flynn and Merry Levenson. "Admiral" and WTIC radio personality Ray Dunaway looks on. (RRI.)

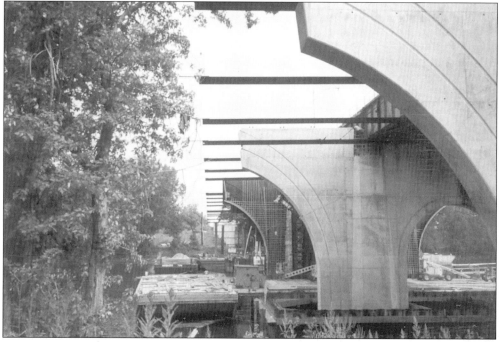

The 1958 Founders Bridge needed a total rebuilding. In stages, lane by lane, pier by pier it was replaced without interrupting traffic. By August 26, 1994, the graceful piers of the new Founders Bridge had emerged from their frames.

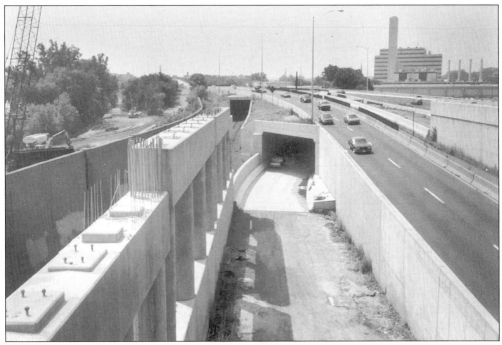

By July 15, 1997, much of the complicated task of moving the highway beneath the Founders Bridge had been completed. The new path is visible on the right. The new entrance tunnel from Columbus Boulevard is nearing completion. The task required the replacing of the original contractor and the moving of the completion date from 1996 to 1999. (DOT.)

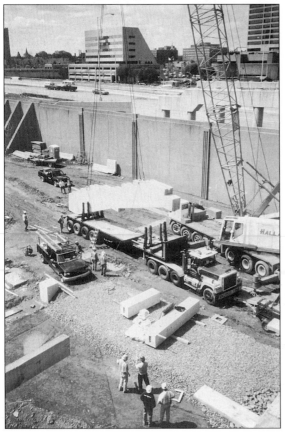

By the summer of 1998, the contractor had begun to install the precast concrete pieces that became the grassy terraces between the riverfront plaza and the river. (RRI.)

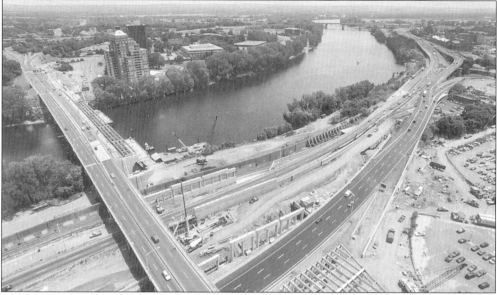

This aerial view, taken in July 1997, shows the scope of the project. The piers and steel skeleton for the new landing are on the right. The lanes for Interstate 91 are being formed beneath the Founders Bridge. (DOT.)

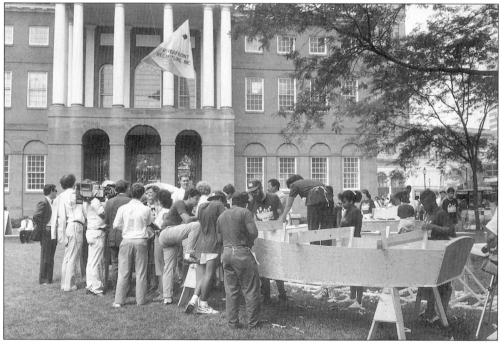

In the summer of 1996, Riverfront Recapture created a youth employment program and hired inner-city youngsters to build boats for the Community Rowing Program. The boats were built on the grounds of the Old State House. This enabled office workers and tourists to learn about the program and to learn from the youngsters who were building the boats. The program attracted national attention and produced a fleet of boats. Sponsors of the boats included the YMCA, actor Paul Newman's Hole in the Wall Camp, and People's Bank. (RRI.)

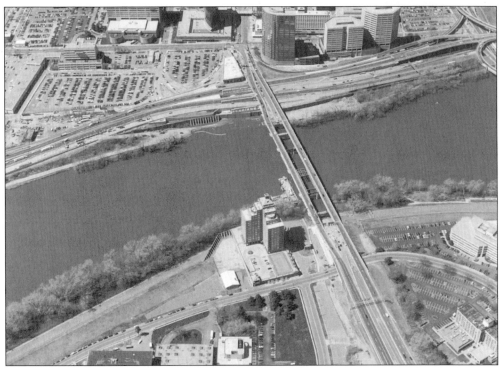

This photograph shows the Founders Bridge as it looked on April 7, 1998. After the left side was completed, the center lane was removed so that it could be rebuilt. Only then was the right lane rebuilt. It was a delicate balance to keep the traffic moving while building the new bridge. (DOT.)

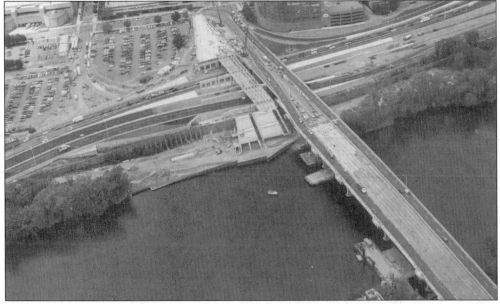

Great progress is evident is this view of the Founders Bridge, taken on July 9, 1998. The first stage of the landing over Interstate 91 is in place, and the center of the bridge has been completed. The landing itself is beginning to take its final form. (DOT.)

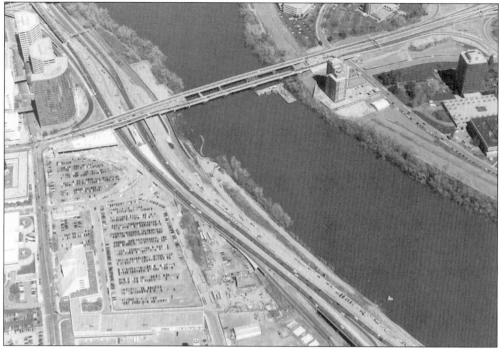

All projects take years to plan and to schedule, and all seem to take forever before any progress is seen. Then, suddenly everything comes together and blossoms. The above photograph shows the riverfront project as it looked on April 7, 1998. The lower view shows the project as it looked in September 1999; now it looks as if it has always been that way. (DOT.)

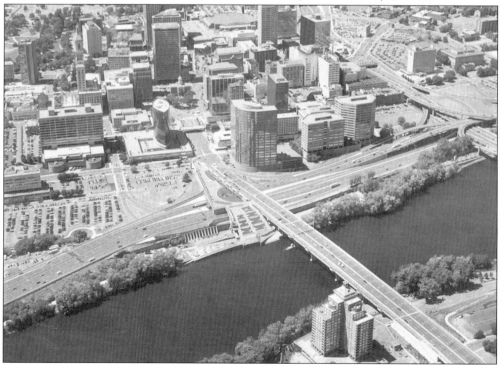

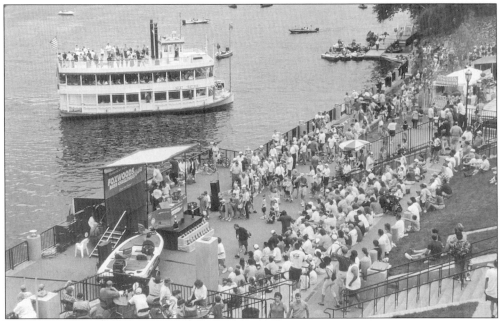

On September 3, 1999, after 18 years of hard work and planning, the new riverfront landing and plaza and the Founders Bridge Promenade were officially dedicated and opened to the public. Thousands came to the river over the Labor Day weekend. They confirmed to all that the vision and tenacity of Riverfront Recapture and its executive directors Jill Diskan, Al Gatta, Denise Nappier, and Joe Marfuggi were something to be very grateful for. (RRI.)

This photograph shows the riverfront landing and the Founders Bridge Promenade as they looked on the eve of the project's official dedication, September 2, 1999. It is interesting to compare this view with earlier ones in the book, especially those on pages 14, 16, and 17. (RRI.)

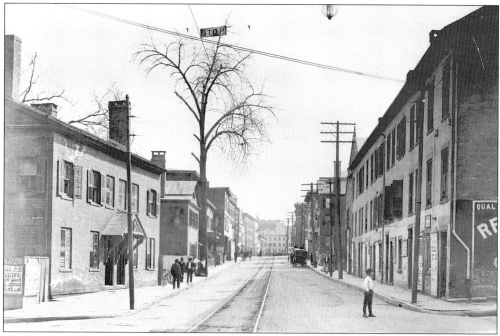

This view of Market Street at the corner of Talcott Street was taken looking south to State Street *c.* 1900. The American Hotel, at the end, had the address One American Row. Visible on the right is the peak of the 1855 church. This church began as an Episcopal mission. In 1880, it was sold to the Lutheran Church. In 1889, it was reconsecrated as St. Anthony's Roman Catholic Church. (Connecticut State Library, Taylor Collection No. 252.)

This is the same corner of Market and Talcott Streets as it looked in the summer of 1999. The church is the Catholic Bookstore. Beside the church are preserved the graves of Dr. Norman Morrison and his son (1795, 1759). The Market Street entrance to the former G. Fox was remodeled in the 1980s. The Phoenix now has the address One American Row. (Old State House.)

S-A

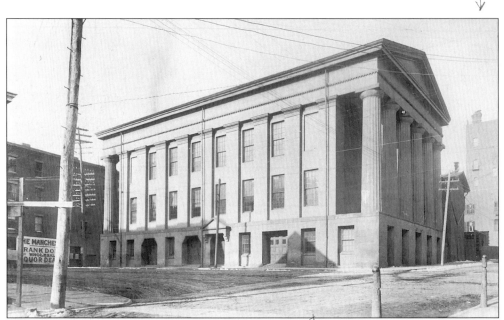

Hartford's City Hall was this stately 1829 building. It stood on the corners of Kinsley and Market Streets, above, and Market and Temple Streets, below. It is believed that Ithiel Towne designed it. The lower floor was used for the market; note the wide wagon-sized openings. The second floor was used for offices. On the top floor was a great assembly room. In 1879, when the city moved to the Old State House, the building became the Police Court. It was demolished sometime after 1917. (Connecticut State Library, Taylor Collection No. 240, No. 239.)

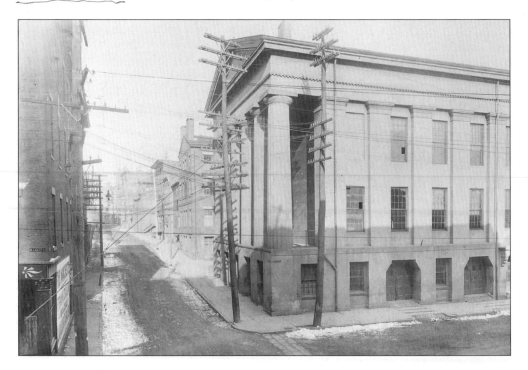

Kinsley Street was named for Dr. Apollos Kinsley, who lived in the center small building, which he is said to have built in 1795. Kinsley was a prolific inventor; he patented a brick-making machine and a steam roadwagon, among other inventions. Kinsley Street once ran from Market Street west to Main Street. In the construction of Constitution Plaza, it was extended east to Columbus Street. In 1985, the Market-to-Main-Street section was absorbed by State House Square. (Connecticut State Library, Taylor Collection No. 245.)

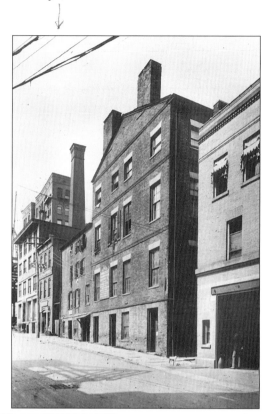

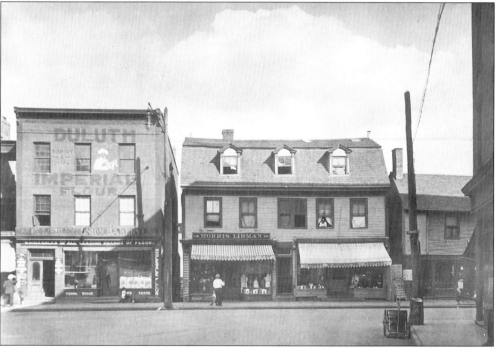

At the foot of Temple Street on Front Street was the birthplace of Mary Talcott. Later, Wachtel's Live Wire Department Store replaced the house. (Connecticut State Library, Taylor Collection No. 237.)

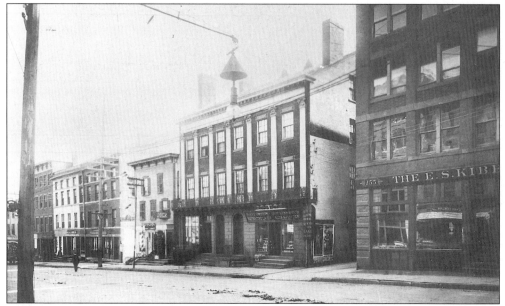

On State Street, just below the Old State House, stood this high-style residence built for Frederick Bange in 1815. In time, the family moved out, and the building became an alehouse, selling "extra fine lager, ales, and porter." Note the elegant cast-iron railing on the balcony. (Connecticut State Library, Taylor Collection No. 232.)

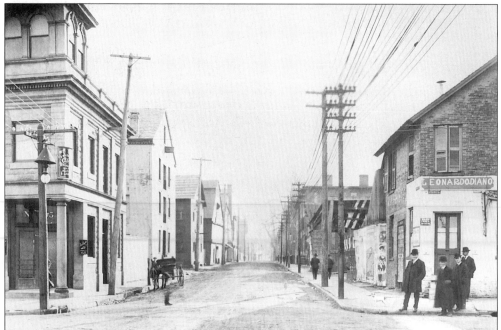

Commerce Street was one of the city's earliest streets. It appears on the first formal city map of 1790. It ran from lower State Street south to Sheldon Street. As the name indicates, it was a street of warehouses and buildings to serve the busy port of Hartford. Part of the street was taken for the 1944 dike. The rest was taken in the new layout for Columbus Boulevard in 1963. (Connecticut State Library, Taylor Collection No. 248.)

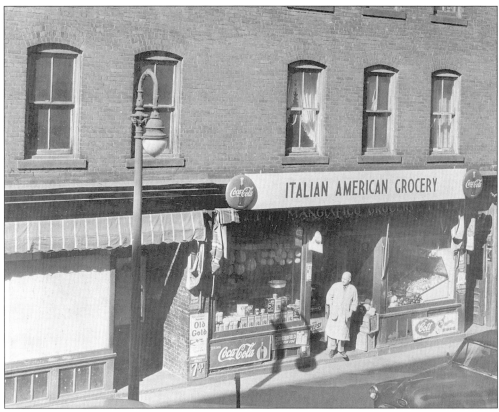

Many people have fond memories of Front Street. It was like New York's lower east side: a closely knit neighborhood with businesses, such as Mangiafico's Italian American Grocery, that were run by the owner, who lived above the store with his family. By 1955, however, most of the buildings were empty, and Front Street was a very dangerous place. The area was razed for Constitution Plaza and the new State Street. Front Street was renamed Columbus Boulevard under this urban renewal project. (Hartford Public Library, Times Collection No. 97.)

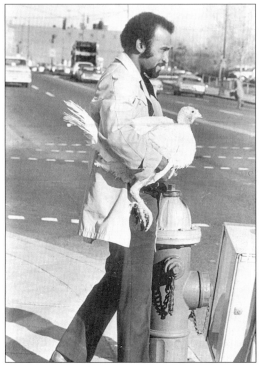

The last purveyor on Front Street-Columbus Boulevard was "the Chicken Man," from whom Edison Ortiz, shown here, bought his fresh Thanksgiving turkey in 1972. The Chicken Man sold fresh chickens, turkeys, and other fowl in his store on the corner of Front and Grove Streets. (Hartford Public Library, Times No. 902C.)

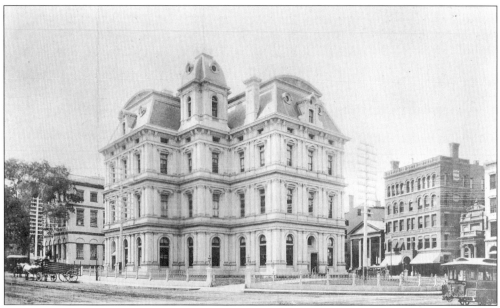

This is how the 1872–1878 post office looked when it was first built on the east lawn of the Old State House. The Old State House is on the left, and State Street is on the right. (Connecticut State Library, Taylor Collection No. 27.)

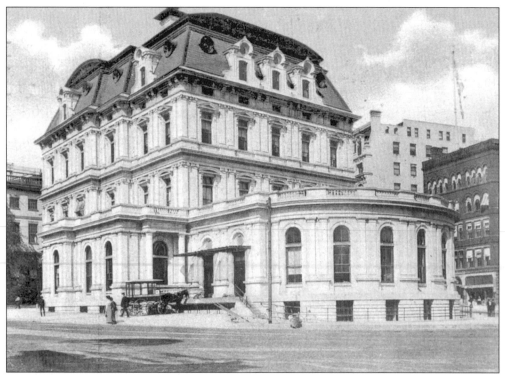

In need of more room, the post office expanded c. 1905. The east façade was squared off, the tower was eliminated, and a wing was added that completely absorbed the east lawn of the Old State House. (Old State House.)

Two
OLD STATE HOUSE

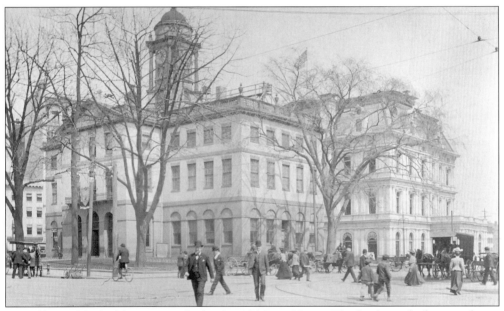

The oldest public building in Hartford is the Old State House. The land on which it stands was set aside in 1636 for the first Meeting House. Later meetinghouses were built here. In 1796, the State House, designed by Charles Bulfinch, was built. This building is known today as the Old State House. From 1796 to 1878, it served as the state capital. From 1878 to 1915, it served as city hall. From 1915 to 1975, it served multiple purposes—space was use for the war bond effort, the Hartford Symphony offices, the Red Cross, the drive to save the Mark Twain House, the Chamber of Commerce, a museum for the Connecticut Historical Society, and the Houses of Comfort (public rest rooms). In 1975, a group of citizens—including Joan Friedland, Morrison Beach, Elizabeth Capen, Bob Smith, and Stanley Schultz—rallied others to save the landmark from the proposed demolition for a parking garage.

This 1890s photograph taken from Main Street shows the Old State House and the post office behind it. (Connecticut State Library, Taylor Collection No. 131.)

After years of encroaching on the Old State House, absorbing its great east lawn, and even trying to move the landmark to Batterson Park in Farmington, the post office lost. In 1934, it was torn down, and the east lawn was restored. It should be noted that the foundations of the post office remain beneath the lawn. What will the archeologists think 1,000 years from now? (Old State House No. 322.)

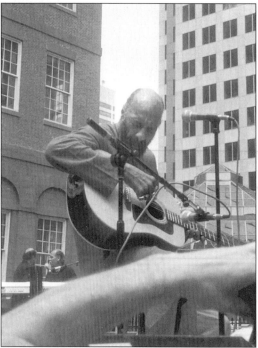

One never knows what will happen next or whom one will meet at the Old State House. On June 25,1999, WHCN 105.9 FM, Fordham Distributors, Trout Brook Brewing Company, presented the Shaboo All-Stars, with special guest Richie Havens in a free concert. (Old State House.)

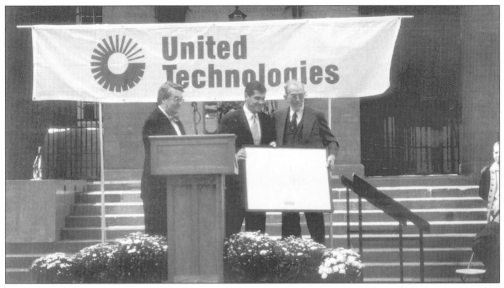

One of the greatest honors one can receive is the Ancient Burying Ground's Thomas Hooker Award. It is given to individuals for extraordinary leadership. On September 24, 1998, the award was presented at the Old State House to Mercedes Croutch of the Women's League Child Development Center. The award was also given to Geno Auriemma, coach of University of Connecticut women's basketball, who is shown flanked on the left by Wilson H. Faude of the Old State House and on the right by Shepherd Holcombe, chairman of the Ancient Burying Ground. (Old State House.)

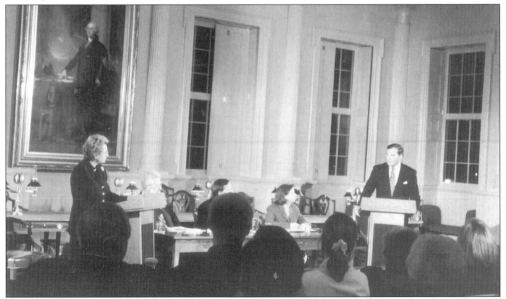

History repeated itself as Rep. Barbara Kennelly, left, and Gov. John G. Rowland held the only live debate in the campaign for governor on October 13, 1998. Sponsored by Connecticut Public Television, the debate took place in the great Senate Chamber and was broadcast live on CPTV, with Channels 3, 30, and 61 carrying updates, and with reporters from the *New York Times*, the *Hartford Courant*, the *New Haven Register*, the *New London Day* and the *Journal Inquirer*. (Old State House.)

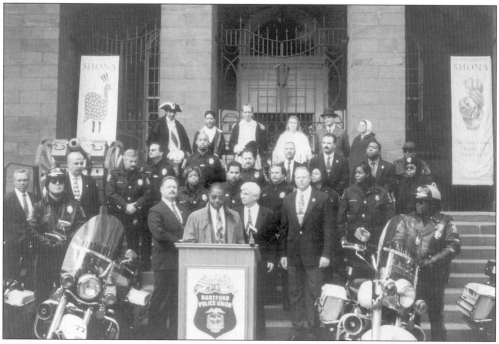

Political endorsements have happened on the site of the Old State House since 1636. On October 22, 1998, Sen. Christopher Dodd received the support of the Hartford Police Union on the east steps. (Old State House.)

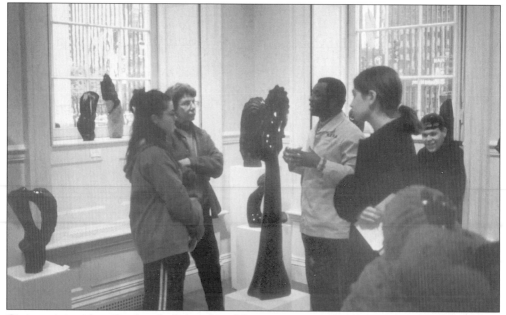

Civic activist Alyce Rawlins had the idea of featuring contemporary sculpture from Zimbabwe to benefit the John Rogers Center and the CRT Craftery. The event, entitled SHONA, was held from October 1 to November 7, 1998. It attracted thousands of people and featured more than 300 works of art, all for sale. In the center, sculptor Zacharia Nojobo shares with students the meaning of one of his works. (Old State House.)

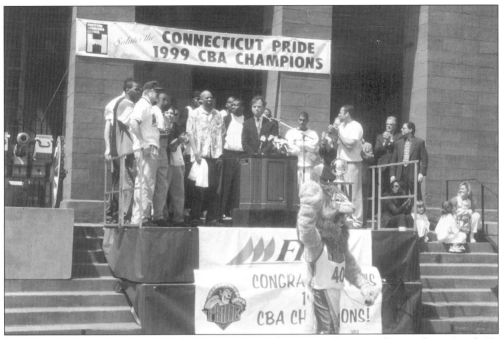

The Connecticut Pride basketball team won the the CBA championship and on April 29, 1999, celebrated the honor with a public rally on the east steps of the Old State House. Brian Foley, team owner, addresses the fans, as the Connecticut Pride's mascot and team members look on. (Old State House.)

Having an acre of lawn in the center of the city presents opportunities for all. The United Way annually holds a whiffle ball swat fest on the lawn, with Jay Sarles pitching. (Old State House.)

Old State House board member Kevin O'Connor of Day Berry and Howard had the idea of holding gatherings at the Old State House for young professionals as an opportunity for them to meet. The first gathering, held on June 17, 1999, was entitled Sizzling State House Summer Night and featured the music of the Savage Brothers. Sponsored by People's Bank, the Old State House, and Access Hartford, the event was a great success and attracted more than 350 people. (Old State House.)

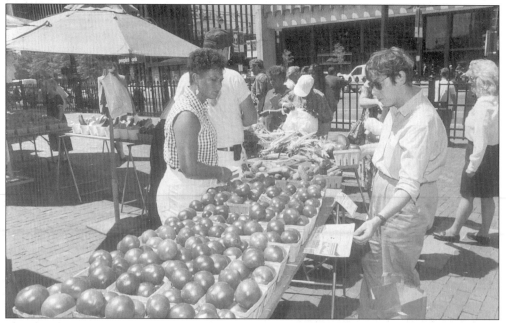

Shortly after arriving in Hartford in 1636, the Connecticut Colony authorized a farmers' market on the grounds of the Meeting House. Market Street got its name for being the street that led to the market on the site of the Old State House. Today, more than three and one-half centuries later, farmers still bring their produce to the Old State House, continuing the tradition. (Old State House.)

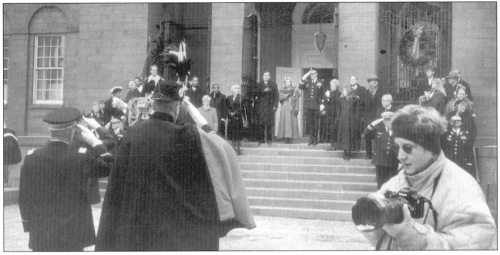

The inauguration of a Connecticut governor is a great state occasion. On January 6, 1999, Hon. John G. Rowland, with Mrs. Rowland, in the center on the top step, began the official march to the capitol from the Old State House. Also standing in the center on the steps are, from left to right, Nancy Wyman, state comptroller; Kathleen Palm, Hartford city treasurer; Gen. David Gay; Lt. Gov. Jodi Rell; Susan Bysiewicz, secretary of state; and Michael Peters, mayor of Hartford. The commandant of the First Company Foot Guard is in the foreground. (Old State House.)

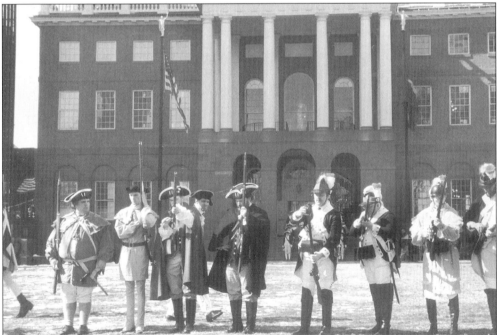

Washington's Birthday in February is always celebrated by the Old State House in grand style. The 2nd Connecticut Regiment, the 17th Connecticut Regiment, and Sheldon's Horse Troop prepare to fire a salute in honor of George Washington, just as they did on the very same site on September 20, 1780, when Washington met for the first time with the commanders of the French armies in America. (Old State House.)

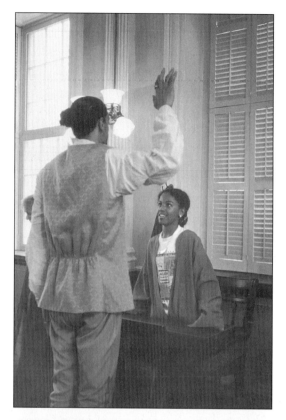

With the Old State House as the setting, students participate in the democratic process, just as legislatures have done here for more than 200 years. Titled Three Branches of Government, students elect a governor, pass legislation, and participate in a trial. At left, the student bailiff for the trial swears in historic interpreter Jorge Erazo. Below, students cast their vote for a governor. Some 40,000 schoolchildren participate annually in the Old State House school programs. (Old State House.)

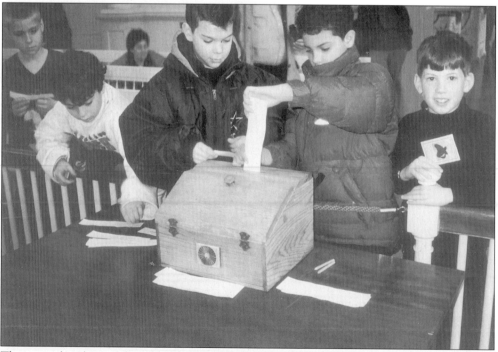

The great chambers of the Old State House are a natural for historic reenactments.

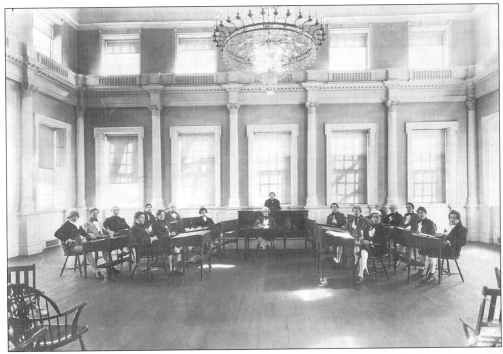

In this photograph, dating probably from 1935, which was the 300th anniversary of the founding of the state, a group of Hartford public high school teachers have donned wigs to debate in the Senate Chamber. Presided over by Clement C. Hyde, the group includes Ray Arnold, far right, and others whose identities are still being sought. (Tina Thompson, Old State House.)

The Amistad Trial began in the Senate Chamber of the Old State House on September 17, 1839. Today, the trial is relived, as historic interpreters reenact the events in the very chamber where it all began. Ralph Ingersoll NH? (Michael Salveggio), the attorney for the slave owner, comforts his client Don Pedro Montez (Jorge Erazo). The Amistad reenactment has been presented more than 300 times and is still performed for school groups and the general public. (Old State House.)

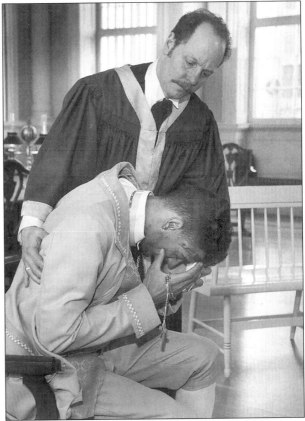

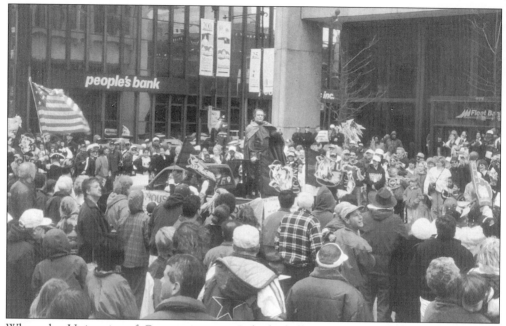

When the University of Connecticut men's basketball team won the National Collegiate Athletic Association (NCAA) championship, Hartford decided to hold a celebratory parade on April 17, 1999. Thousands lined the streets to cheer the bands, the floats, and the team. The Old State House participated with its interpreters and a "living statue" of Connecticut founder Rev. Thomas Hooker (Wilson H. Faude). The crowds were more than startled when the statue winked at them. (Old State House.)

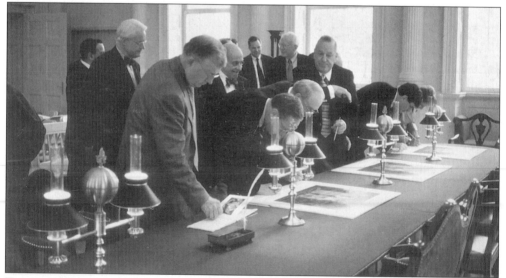

Trinity College was chartered in the Senate Chamber of the Old State House on May 16, 1823. On May 22, 1999, the trustees of Trinity, under the leadership of Thomas S. Johnson, chairman, and Evan S. Dobelle, president, voted to preserve and endow the Senate Chamber in recognition and commemoration the chartering and in celebration of the 175th anniversary. Shown here are members of the Trinity Board of Trustees signing the commemorative documents of the event. (Old State House.)

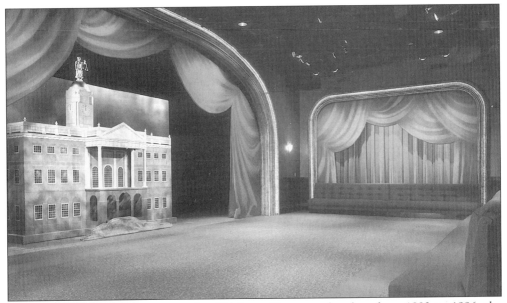

During the heroic renovations to the Old State House, undertaken from 1992 to 1996, the landmark received new foundations and a great space was added beneath the west plaza. When the original tenant decided not to come, the Old State House created a magical theater in part of the space. Designed by Jeff Cowie, the theater is resplendent with its red velvet curtains and gold-framed arches. The space is used for lectures, theatrical events, and films. Below, one of the principal tenants is the American Puppet Theater, which presents great Connecticut stories, such as "The Legend of the Charter Oak," to the delight of all. (Old State House; Benson.)

State Street, beside the Old State House, is one of Hartford's earliest streets. Shown is the 1834 First National Bank, right, and the United States Hotel, left. The revenues collected by the state on the establishment of the bank allowed the state to add the great lawn to the Old State House and the ornamental fence of Roman axes and pickets topped with Charter Oak leaves. (Connecticut State Library, Taylor Collection No. 235.)

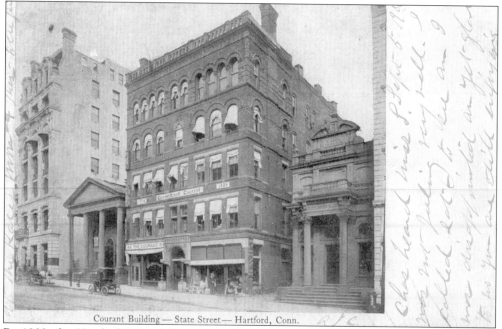

Courant Building — State Street — Hartford, Conn.

By 1900, the Hartford Federal Savings building, designed by Ernest Flagg of New York, had replaced the hotel on State Street. The bank remained, and in 1880, the Connecticut Courant erected its modern office building. The hotel and the bank were gone by the 1950s, when the W.T. Grant department store took their place.(Old State House.)

During the redevelopment boom of the 1980s, all of State Street was obliterated, except for the Hartford Federal building. The other buildings were replaced by State House Square, with its faceless design, and the street was closed to cars. What had been the busiest thoroughfare in the city became one of the quietest. (Old State House.)

Built originally for the Connecticut Bank and Trust Company, One Constitution Plaza was designed by Kahn and Jacobs of New York in 1964. The original glass was later covered with a black film. In the summer of 1999, all the glass was replaced by a green-tinted glass. Today, One Constitution Plaza is billed as "Hartford's newest skyscraper," and it is again seeking occupants. (Old State House.)

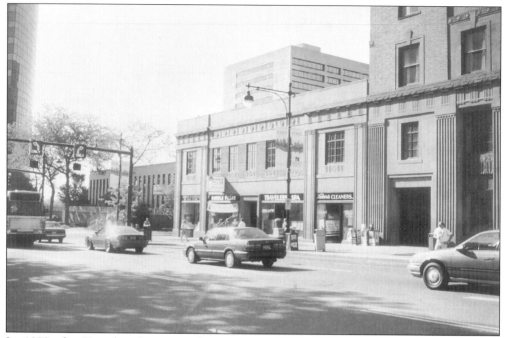

In 1938, the Travelers Insurance Company razed the Morrison House (see p. 108) and commissioned Smith and Bassette to design the building shown here. For years, the four occupants of the building were, above from the left, the Christian Science Reading Room, the Marble Pillar, the Travelers Spa, and Howard's Cleaners. After the depression of the early 1990s, below, the three businesses were gone, leaving only the Christian Science Reading Room on the corner. In 1999, Almada Shoe Repair and the Java City Café were located beside the Christian Science Reading Room. (Old State House.)

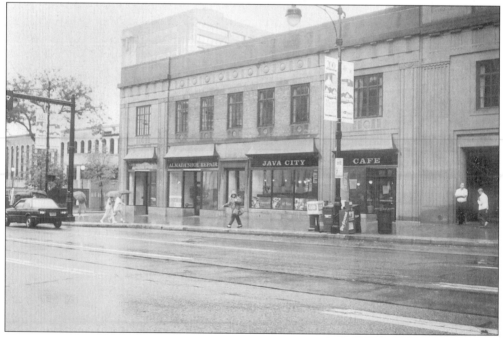

Three

NONPROFITS LEADING THE WAY

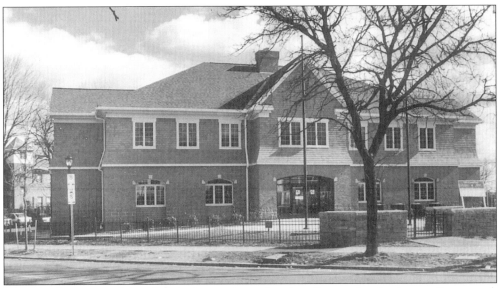

After the depression of the 1990s had more than taken its toll, countless businesses disappeared, and downsizing occurred in staggering numbers. It was a depression with all its bleakness. In the middle of this, real leadership and tenacity arose from a most unlikely source: the not-for-profits. The boards of directors found not only the vision and the mettle to dream for their institutions, but also the strength to achieve the goals under most adverse or seemingly adverse conditions.

The Connecticut Valley Girl Scout Council, in order to better reach its clients, decided to build a new centrally located headquarters. Designed by Moser Pilon Nelson Architects of Wethersfield, the new headquarters building is located at the corner of Washington Street and Retreat Avenue. The building opened to the public on March 28, 2000. (Moser Pilon Nelson Architects.)

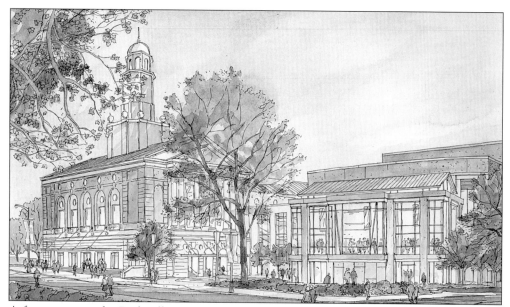

A few years ago, the Bushnell was facing an uncertain future. Instead of hiding in the past, it reached out, embraced the blockbuster musical, and brought thousands to the main hall and millions of dollars in support. To better meet the needs of the community, it planned a second stage, the Bushnell II, shown here beside the great hall. (Bushnell.)

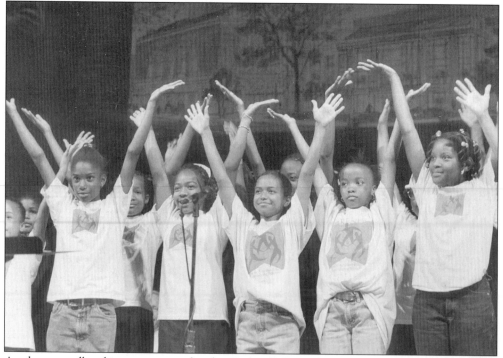

At the groundbreaking ceremony for the Bushnell II, on June 14, 1999, the students from Hartford's Annie Fisher School performed. They were terrific! (Giroir Photography, Bushnell.)

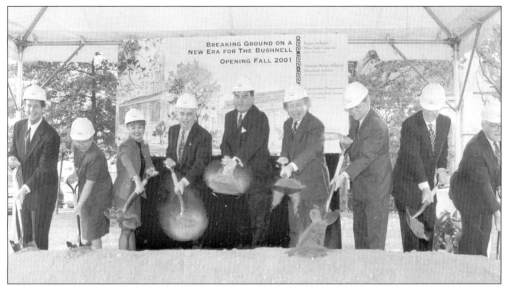

No groundbreaking is complete without the hurling of dirt, at least ceremonially. The Bushnell assembled a splendid cast to do the deed. From left to right are Douglas Evans, executive director of the Bushnell; U.S. Rep. Nancy Johnson; Marilda Gandara Alfonso, chair of the education committee; Sen. Christopher Dodd; Gov. John Rowland; Sen. Joseph Lieberman; Rep. John Larson; Ronald Compton, chair; and Arnold Greenberg, president of the Bushnell. (Giroir Photography, Bushnell.)

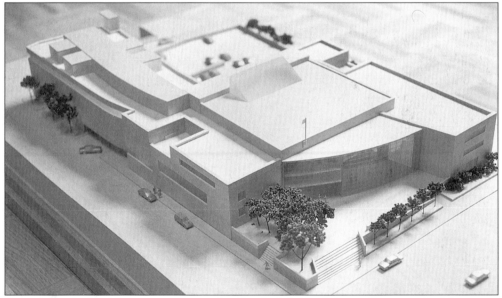

One of Hartford's oldest institutions is the Hartford Public Library. For years the library was located in the Wadsworth Atheneum. In 1957, it moved to 500 Main Street. That building, designed by Schutz and Goodwin, was constructed with thrift in mind; thus, by 1998, it needed to be upgraded and modernized to serve the library's 600,000 patrons. Through the leadership of librarian Louise Blalock and city officials, a bond referendum was approved by the voters. Ray Sevigny designed the renovations and the expansion. Groundbreaking for the project was on October 28, 1999. (Hartford Public Library.)

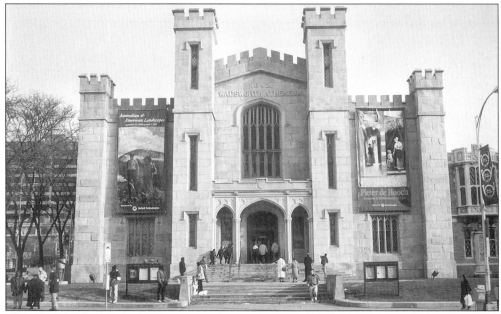

The Wadsworth Atheneum is one of America's premiere art museums. Although its 1842 castlelike exterior has been carefully preserved, the front elevation has been lowered some 8 feet. Compare this 1999 view with the 19th-century view on page 91. Leadership from the Wadsworth Atheneum came in the form of first-class quality exhibitions, as the banners proclaim: Australian & American Landscapes from September 11, 1998 to January 3, 1999, and Pieter de Hooch from December 18, 1998 to February 28, 1999. Both exhibitions were generously sponsored by United Technologies. (Wadsworth Atheneum Archives.)

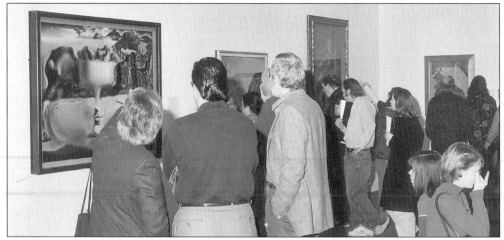

The first American museum to purchase a Salvadore Dali painting was the Wadsworth Atheneum in 1936, when director A. Everett Austin purchased *Apparition of a Face and Fruit Dish on a Beach*. In 1997, Wadsworth Atheneum director Peter Sutton decided that the Dali connection should be celebrated, and the decision was made to create the special exhibition Dali's Optical Illusions. Sponsored by United Technologies, the exhibition had its press preview on January 20, 2000, and ran through March 26, 2000, bringing thousands of new visitors to Hartford. Shown is the Dali exhibition; the painting on the left is the one purchased in 1936. (Wadsworth Atheneum Archives.)

Perhaps the Wadsworth Atheneum's most celebrated director was A. Everett "Chick" Austin Jr., who transformed the stodgy bastion of Yankee 18th-century sentiments into the pioneer of 20th-century attitudes and experiments. In 1930, Austin and his wife, Helen Goodwin Austin, commissioned Leigh French to design this Andrea Palladio-style house for them on Goodwin land at 130 Scarborough Street in Hartford's west end. The Austin family later gave the house to the Wadsworth Atheneum, and it is now undergoing a thoughtful restoration, overseen by museum archivist Gene Gaddis. (Wadsworth Atheneum Archives.)

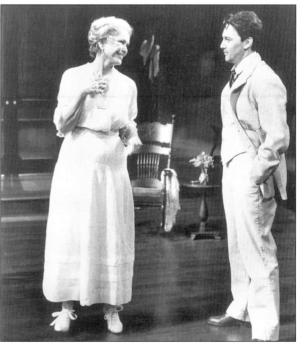

Like many great ideas, the creation of the Hartford Stage happened around a kitchen table—Jack Huntington's. The theater opened on Market Street on April 1, 1964, with *Othello*, directed by Jacques Cartier. Today, the artistic director is Michael Wilson, and the theater continues to draw favorable notices internationally. Eugene O'Neill's *Long Day's Journey into Night*, starring Ellen Burstyn and Andrew McCarthy, ran from February 25 to April 1, 1999. (Hartford Stage.)

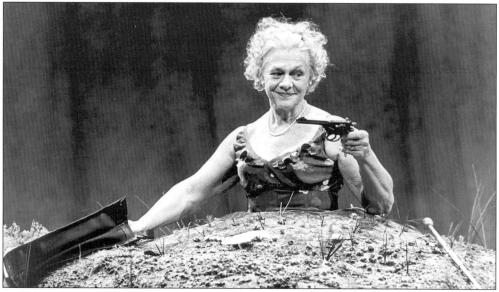

Perhaps the most challenging play presented by the Hartford Stage in 1999 was Samuel Beckett's *Happy Days*, directed by Richard Block and starring Estelle Parsons. (Hartford Stage.)

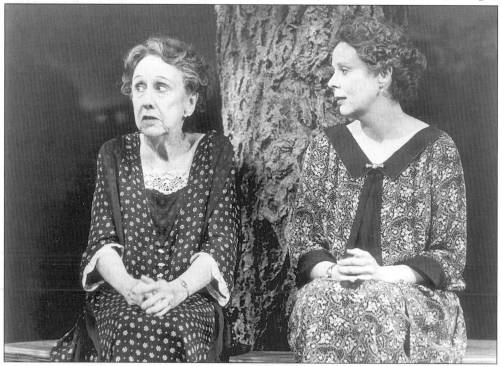

If there is one word to describe the Hartford Stage, it is quality. Michael Wilson has continued the tradition of excellence that has made the theater's reputation and made it possible for it to attract first-rate actors and actresses. In *The Death of Papa*, by Horton Foote, Jean Stapleton, left, discusses the future of the Vaughn family with her sister, Julie Fishell. The play ran from May 27 to June 27, 1999, and was so successful that the run was extended another two weeks. (Hartford Stage.)

Four

TRINITY COLLEGE,
QUINTESSENTIAL LEADERSHIP

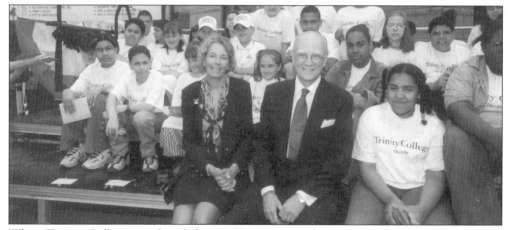

When Trinity College was founded in 1823, it was an alternative to the domination of the Congregational Church at Yale College. The college's first permanent buildings were atop Bushnell Park. When the state decided to have one capital in Hartford, Trinity sold its buildings to the state and purchased the present site. The neighborhood grew and then fell into disrepair. The abandoned bus depot on Broad Street, occupying some 16 acres on the college's east border, was for most a problem of insurmountable proportions. In 1995, Trinity appointed Evan S. Dobelle president. Dobelle, a man of vision, saw the derelict acreage as an opportunity. The acreage that no one wanted has become the Learning Corridor, a $175-million neighborhood revitalization initiative. Trinity created a partnership with the Southside Institutional Neighborhood Alliance. The Learning Corridor is home to a Montessori school, a middle school, an academy of math and science, an academy for the arts, and the Ann and Thomas S. Johnson Boys and Girls Club. The heart of the project is the Ann and Thomas S. Johnson Boys and Girls Club building. It is the first one in the country that is part of a college. As the chair of the Trinity Board of Trustees, Johnson understood Trinity's commitment. He and his wife donated the funds to see that the Boys and Girls Club would be built. At the dedication, the Johnsons sat with some of the boys and girls who would use the club. (Trinity.)

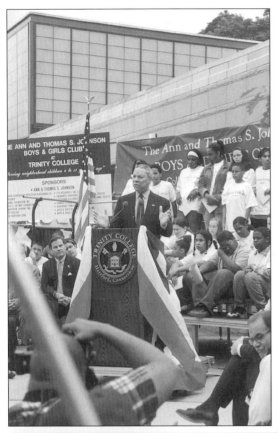

Retired general Colin Powell was the guest speaker at the dedication and opening of the Ann and Thomas S. Johnson Boys and Girls Club, on June 11, 1998. In his remarks, Powell stressed the essential relationship of neighborhood support in the raising of all children and praised Trinity for its leadership and commitment. (Trinity.)

One of the factors that sets the Ann and Thomas S. Johnson Boys and Girls Club program apart from others is the built-in mentoring by Trinity students and faculty. Every day, before the games begin, the youngsters come to the club to do homework and to work on projects. (Trinity.)

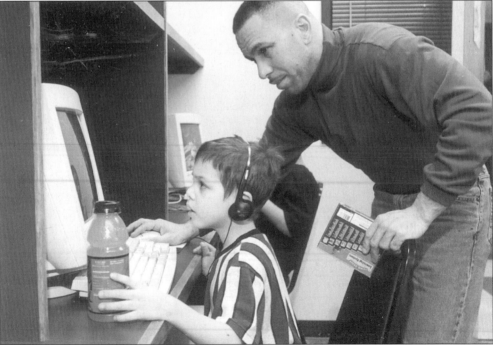

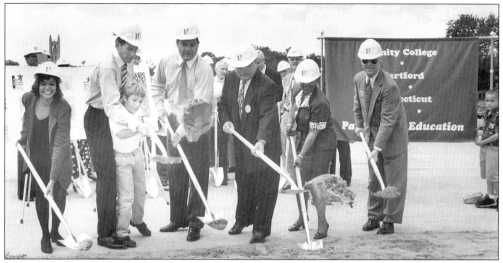

What began as a dream became a reality on July 31, 1997, when ground was broken for the Learning Corridor, dubbed Trinity's neighborhood revitalization initiative. Present to move the dirt, from left to right, are Saundra Kee Borges, city manager; Evan Dobelle, president of Trinity, with son Harry Dobelle; Gov. John Rowland; mayor Michael Peters; Patricia Daniel, superintendent of Hartford Schools; and John Meehan, president of Hartford Hospital. (Trinity.)

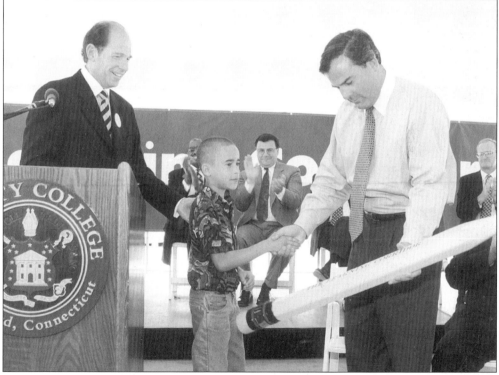

As part of the Learning Corridor's groundbreaking, David Martinez Jr. presented Gov. John Rowland with a giant pencil, as Evan Dobelle, Trinity's president, looked on. The boy's father, David Martinez Sr., was the former president of Hartford Area Rally Together (HART), a citizens group in the Trinity neighborhood. (Trinity.)

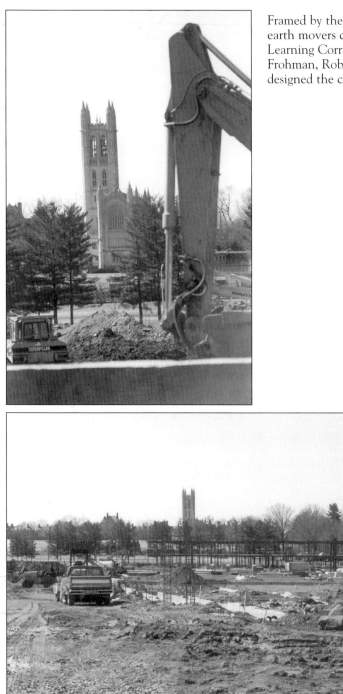

Framed by the Trinity College Chapel, earth movers clear the land for the Learning Corridor project in 1998. Frohman, Robb and Little of Washington designed the chapel in 1932. (Trinity.)

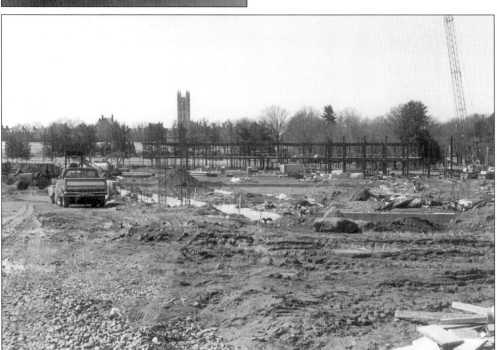

By 1999, steel framing began to rise on the site of the former bus depot. This view from Washington Street looks west to the main Trinity campus. (Trinity.)

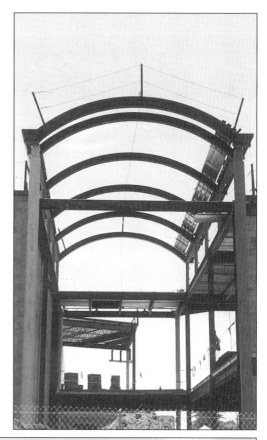

By 1999, the graceful arches of steel had brought to all the full import of the Learning Corridor's impact on the neighborhood. Seeing the site today, one would think that it has always been a jewel in Hartford's crown. It is a testament to the courage and commitment of Trinity to its neighborhood. As Pres. Evan Dobelle put it, "The bulldozer is not the answer; investing in our neighborhood is." (Trinity.)

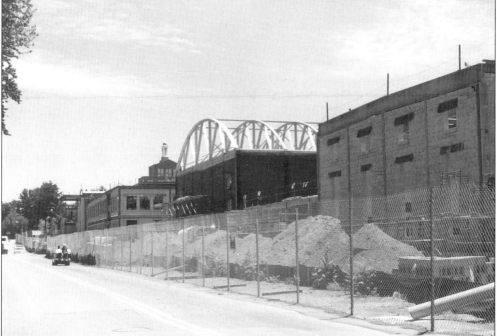

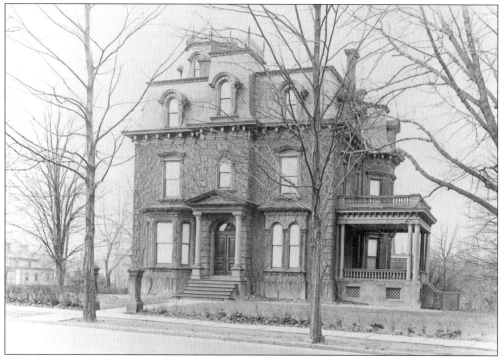

Near Trinity once stood some of the most fashionable mansions in the city. Samuel Taylor photographed this great Victorian pile. It is recorded as the home of Mrs. Hamilton and stood at the northwest corner of Washington Street and Allen Place. (Connecticut State Library, Taylor Collection No. 284.)

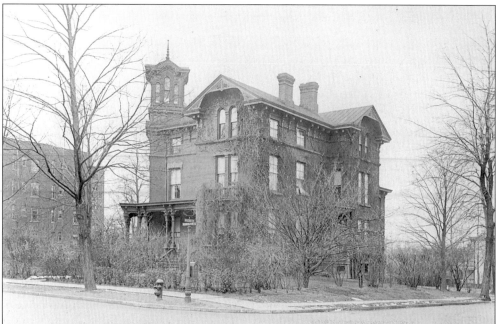

On the southwest corner of Washington Street and Allen Place stood the home of Mrs. George Roberts. Today, this site is a parking lot. (Connecticut State Library, Taylor Collection No. 285.)

In 1892, *Hartford Illustrated* published this view of the southeast corner of Washington Street at Park Street. The house at one time was the home of Trinity's Psi U House. Next-door was the home of Samuel Johnson. (Old State House.)

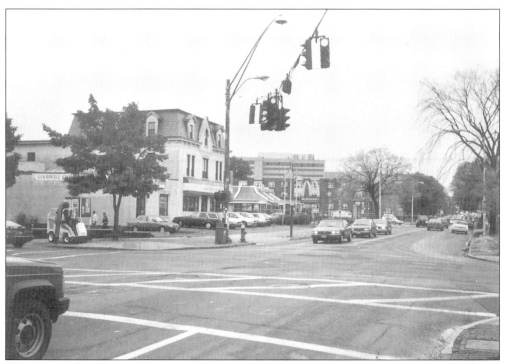

This view of the southeast corner of Washington Street at Park Street was taken in the summer of 1999. The Psi U House is gone, and the Samuel Johnson house has been remodeled and stuccoed. McDonald's now stands next to the Johnson house. (Old State House.)

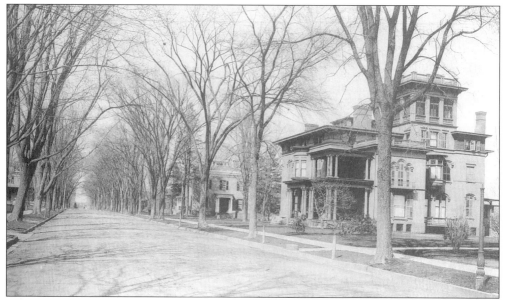

At 130 Washington Street, just north of Park Street, stood the Lucius Barbour House. Built in 1865, the house had a tower that offered a commanding view of the city. (Old State House.)

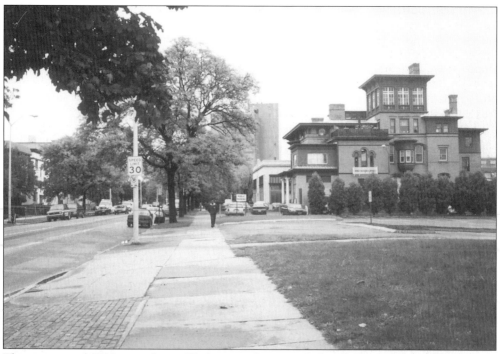

This summer-of-1999 view shows Washington Street and the Barbour House. Although the house survives, it has been remodeled; its porches have been enclosed, and the great porte cochere has been removed. Beyond it are the former car dealerships that dominate the street to the north. (Old State House.)

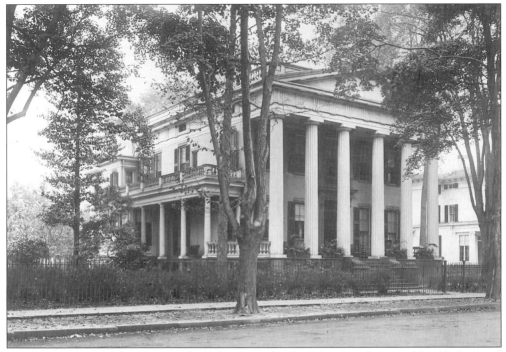

The Leverett Brainard House stood on the west side of Washington Street at No. 95. Brainard served as a member of the city council, in the Massachusetts General Assembly, as mayor in 1894, and as a partner in Case Lockwood and Brainard Printers. As the state government grew and expanded, it needed more land. In time, the Brainard property was purchased and the house was razed. In 1929, the Hartford County Building was erected in its place. It was designed by Paul Cret of Smith and Bassette. The picture below shows the Hartford County Building as it looked in the summer of 1999. (Connecticut State Library, Taylor Collection No. 257; Old State House.)

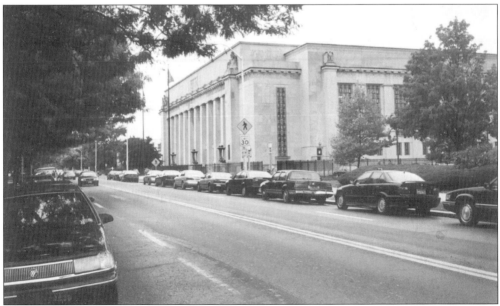

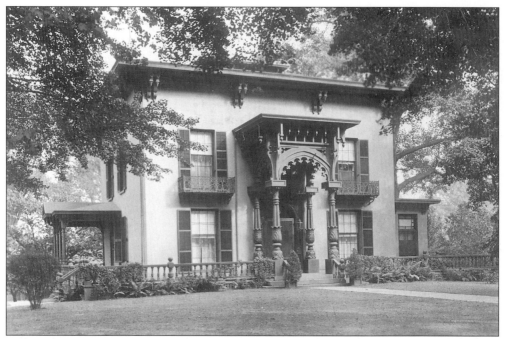

One of the great houses on Washington Street was the Pratt-Northam-Lee-Taylor House. It stood at No. 138 on the east side. Its last owners were the daughters of Samuel Taylor, who took photographs of Hartford buildings and donated the negatives to the Connecticut State Library. (Connecticut State Library, Taylor Collection No. 262.)

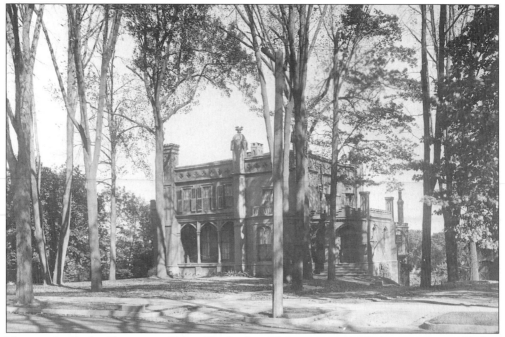

Next to the Taylor House stood Mrs. Charles Jewell's house at 140 Washington Street. Today, 60 Washington Street occupies this site—yes, the street has been renumbered. (Connecticut State Library, Taylor Collection No. 260.)

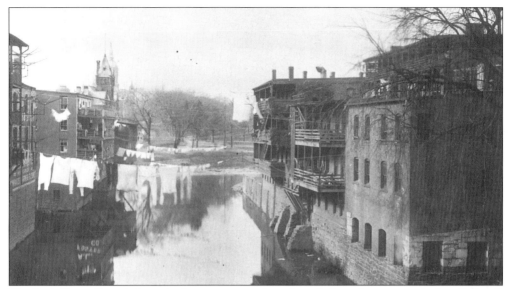

The Park River flowed through the city, its north and south branches joining before Bushnell Park and ending at the Connecticut River. That is how pictures record it. It was also named the Hog or the Meandering Swine because of the odors from domestic and industrial wastes. When the river flooded, it damaged businesses. This 1900 view shows the river from Main Street, looking west to the capitol. The tenants have hung out their wash to dry. The Armory stands at the corner of Elm and Hudson Streets. (Connecticut State Library, Taylor Collection No. 32.)

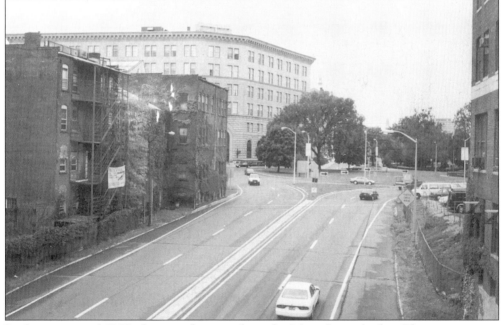

In the summer of 1999, this was the view from the Main Street bridge. The river is gone, enclosed in a pipe in 1944 so that it would not flood. The Armory was replaced in 1924 by the Aetna Insurance Building (Little Aetna). Designed by James Gamble Rogers, the new building was an adaptation of the 15th-century Medici-Riccardi Palace in Florence. The design made sense when the Park River flowed beside the front door. (Old State House.)

63

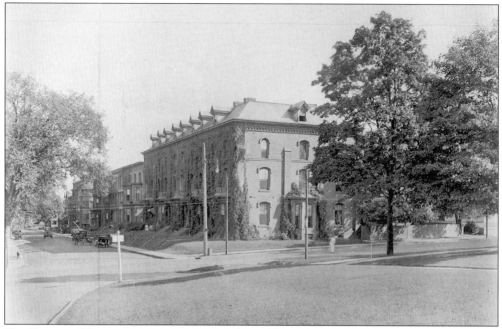

Elm Street at Trinity Street was a most fashionable address. Many prominent citizens lived there, including Dr. Cincinnatus Taft, Mark Twain's physician. This 1900 view looks east down Elm Street. (Connecticut State Library, Taylor Collection No. 275.)

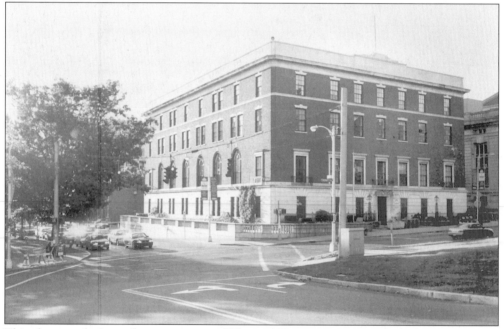

This photograph shows the same corner of Elm and Trinity Streets as it looked in the summer of 1999. The brownstones are gone, replaced in 1917 by this building built for the Phoenix Insurance Company. It was designed by Morris and O'Connor of New York. Today it is a state office building. Because of all the insurance companies located on Elm Street, it became known as Insurance Row.(Old State House.)

The State Capitol was designed in 1872 by Richard M. UpJohn. The Building Committee approved the overall design but did not approve UpJohn's design for the tower. The committee authorized the construction of the basic building. Shown is the capitol nearing completion in 1875, without the dome. The dome was added later as a change order. The interior layout of the capitol reflects the fact that the dome was added later: stairs take abrupt turns, and halls suddenly dead-end. (Old State House.)

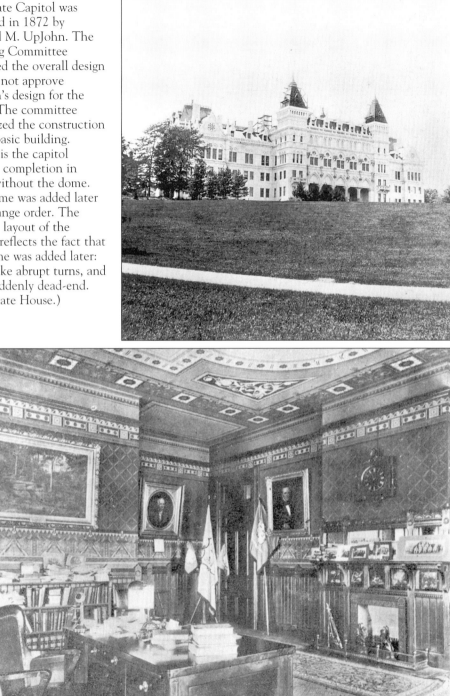

The new capitol was completed in 1879. This is how the governor's office looked when first completed. The ceiling was decorated in the same enthusiastic colors that appear throughout the rest of the building. Portraits of Israel Putnam and Gov. William Buckingham solemnize the space. (Old State House.)

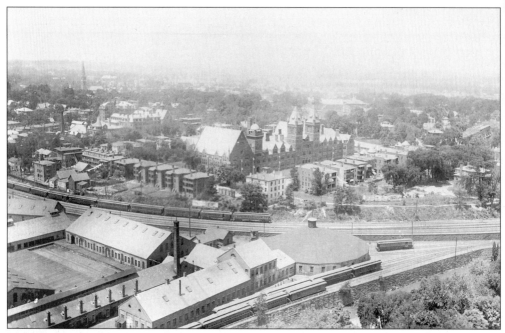

This view was taken from the lantern of the dome of the State Capitol *c.* 1900. In the foreground are the railroad roundhouse and supporting sheds and train tracks. In the center are the great towers of Hartford Public High School. These were demolished in the 1960s to create a path for Interstate 84. It is a shame that the highway had to take this route. (Connecticut State Library Taylor Collection No. 351.)

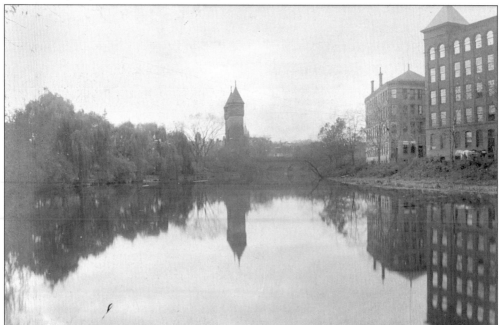

When the Park River ran through Bushnell Park, it created peaceful reflections of the Soldiers and Sailors Memorial Arch, center, and of the Jewell Belting factories on the right, today the site of the Southern New England Telephone Company (SNET). (Old State House, Snow.)

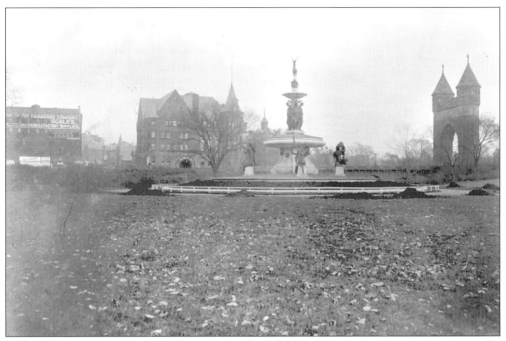

Although no date appears on this photograph of Bushnell Park, the view was undoubtedly taken in November 1899. This date is derived from the scene in the center. The magnificent Corning Fountain looks brand-new and crisp. A gift from the Corning family, it was sculpted by J. Massey Rind of New York. Around it are the telltale piles of dirt, the final grading before the unveiling. Leaves have blown across the lawn. On November 24, 1899, the city formally accepted this fountain; the acceptance would have come only after the final grading was completed. Beyond the fountain are the towers of the YMCA center, with the Soldiers and Sailors Memorial Arch on the right. (Old State House, Snow.)

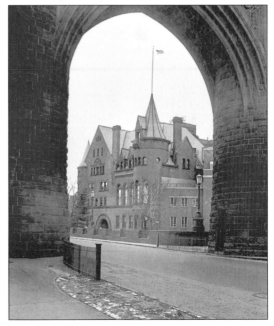

This photograph of the 1893 YMCA, viewed through George Keller's 1883 arch, shows how thoughtfully Edward Hapgood designed the building to fit with the architecture of the neighborhood. It is too bad that in 1974, others decided to tear down the YMCA. (Old State House.)

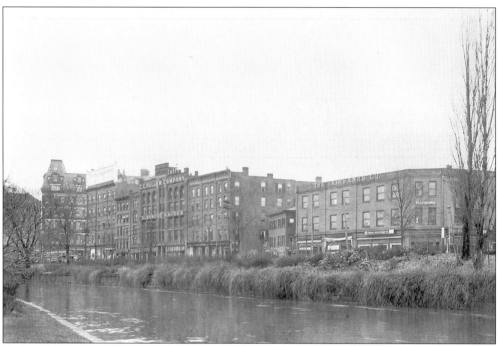

This photograph was taken in Bushnell Park, looking northeast to Ford Street *c.* 1900. The Hotel Garde, at the corner of Asylum and High Streets, is the tall building on the left. (Connecticut State Library, Taylor Collection No. 165.)

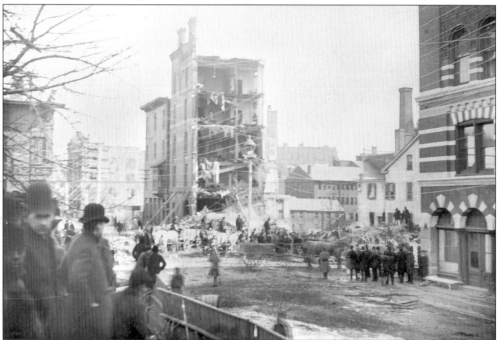

Some buildings have been lost due to disasters. One of those was the Park Central Hotel on High Street. On February 18, 1889, the hotel's boiler exploded, leveling half the building and killing two people. (Aetna No. 511.)

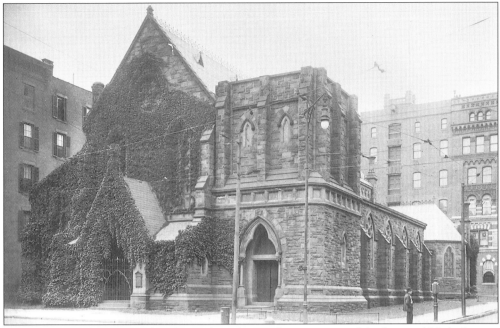

The Park Congregational Church stood on the northwest corner of Asylum and High Streets. It was dedicated on March 29, 1867, and was to have a steeple 184 feet high. This *c.* 1920 view shows the building covered with vines. The base for the steeple is on the right. The place looks abandoned. (Connecticut State Library, Taylor Collection No. 166.)

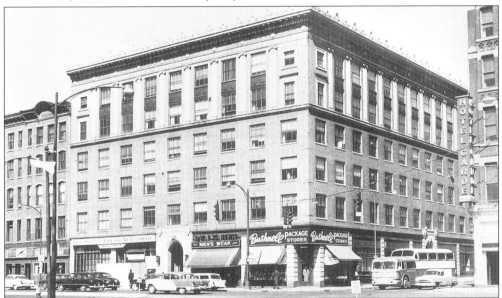

At some point the Park Congregational Church and the neighboring property was sold, and the buildings were razed. In 1926, the Capitol Building was erected on the corner of Asylum and High Streets. Designed by Thomas W. Lamb of New York, the building was the home office for the Capitol National Bank. This 1957 photograph shows the building known today as 410 Asylum, with the Connecticut Bank and Trust on the left and various stores on the right. Its future is at present uncertain. (Hartford Public Library, Times Collection No. 75.)

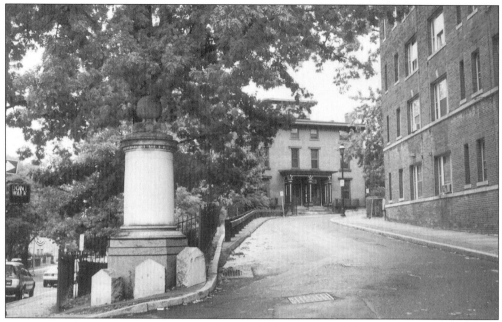

Just east of Main Street at the corner of Charter Oak Avenue is Charter Oak Place. On the corner is this monument. It was designed by Charles Platt in 1905 for the Daughters of the American Revolution to commemorate the great Charter Oak Tree of Connecticut legend, which stood to the west of the site. The apartment building on the right stands on the actual site of the tree. (Old State House.)

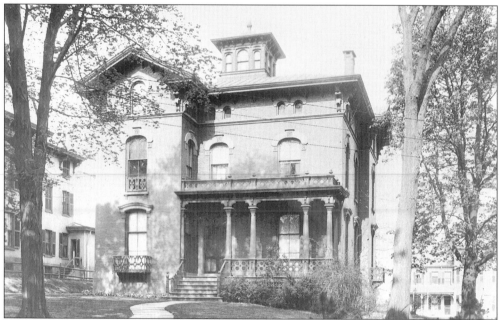

Charter Oak Place once had some of the most fashionable residences in the city. Happily, many of them are still here. This house at 37 Charter Oak Place was the home of Judge Waldo and later the Hyde family. It was demolished and later replaced by the apartment building. (Connecticut State Library, Taylor Collection No. 300.)

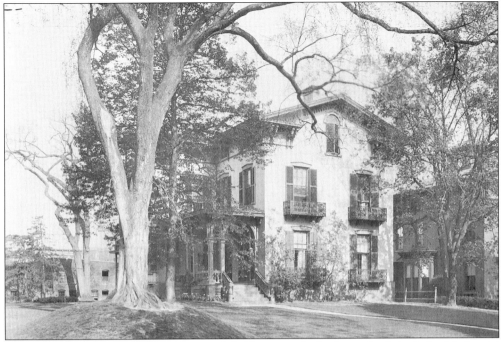

Next to the Hyde House at 33 Charter Oak Place stands the house built by Judge Nathaniel Shipman in 1860. The paneling in the library is reported to be made of oak taken from the Charter Oak. The house remains a private residence. (Connecticut State Library, Taylor Collection No. 299.)

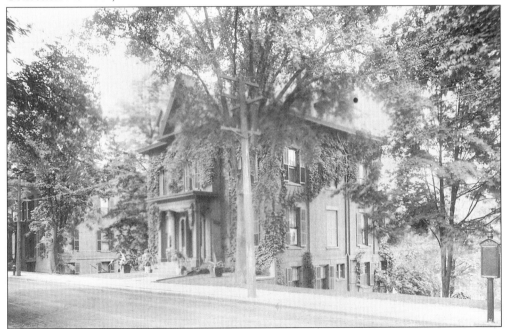

Across the street from the Shipman House stood the home of Samuel Taylor, whose photographic collection is now in the Connecticut State Library. The Taylor House was demolished. (Connecticut State Library, Taylor Collection No. 336.)

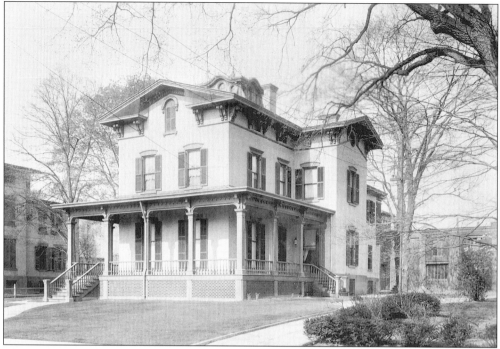

The Kingsbury House at 27 Charter Oak Place was built in 1860 and was later owned by Dr. Richard Gattling, who in 1866 invented the first machine gun. Gattling moved here from Ohio while his invention was being manufactured at Colt's Armory. The house is still a private residence. (Connecticut State Library No. 298.)

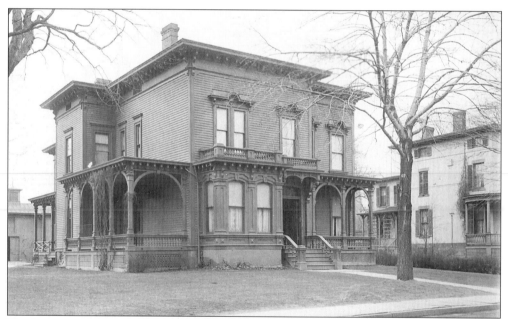

The house at 19 Charter Oak Place was built in 1869 for the James Niles family. Later owned by the Ketridge and the Hillard families, the house is still a private residence. (Connecticut State Library, Taylor Collection No. 302.)

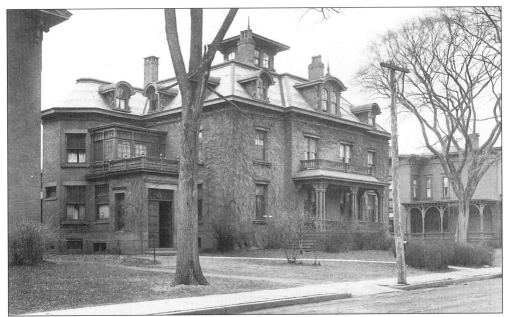

Just south of the Niles House is 15–17 Charter Oak Place. According to the Taylor records in the state library, the house was built in 1864 for James A. Smith. At some point, it was divided into a two-family house. According to the atlases of the day, the property was also owned by the Goodwin Trust. (Connecticut State Library, Taylor Collection No. 304.)

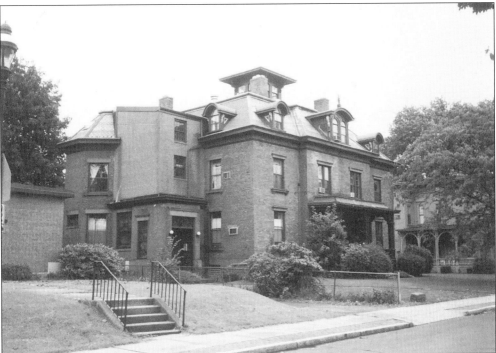

This is how the Smith House at 15–17 Charter Oak Place looked in the summer of 1999. The entrance to No. 15, on the left, has been enclosed and enlarged and the front over-door railing is gone, but the house is in remarkable condition. (Old State House.)

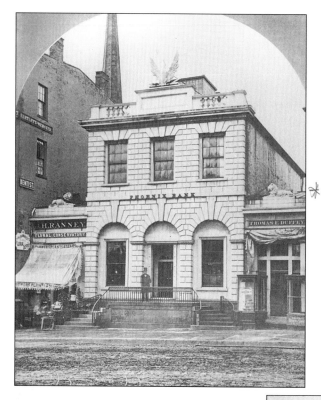

On Main Street across from the Old State House stood the Phoenix Bank. Erected in 1817, it was Hartford's first marble building. The raised entrance also served as a speaker's platform, and many great orators, including Stephen Douglas, spoke here. At the top is a wooden phoenix rising from the ashes. Above the two side wings are the stone lions that now grace the Arch Street entrance to City Hall. (Connecticut State Library, Taylor Collection No. 10.)

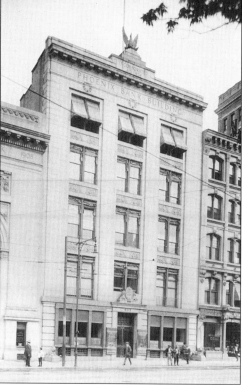

The Phoenix Bank pictured above was replaced by a second bank building, which was in turn replaced by this Phoenix Bank Building c. 1920. Most of the block on the west side of Main Street was be demolished in 1965 and replaced by the concrete "radiator" for Hartford National Bank, which became Connecticut National Bank, then Shawmut, and now Fleet Bank. (Connecticut State Library, Taylor Collection No. 11.)

74

Five

THE CHANGING FACE

OF HARTFORD

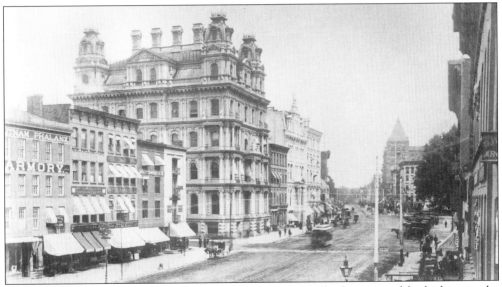

Hartford, like any city, has changed and grown, as is visually documented by looking at the downtown streets and buildings. This photograph of Main Street was taken looking northwest from the corner of Grove Street, by the Travelers Insurance Company. The Putnam Phalanx Armory and the adjoining stores are where the Gold Building now stands. The towering building on the corner of Main and Pearl Streets is the 1870 Connecticut Mutual Life Insurance building. The guidebooks called it "Hartford's greatest office structure." In 1926, Connecticut Mutual moved to its new building on Garden Street and sold the Main Street building to Hartford National Bank and Trust Company. In 1965, the bank tore down most of the Main Street block to build its new home office, as designed by Welton Becket and Associates of Los Angeles and New York. (Connecticut State Library, Taylor Collection No. 28.)

The 1947 Memorial Day parade was a major event, as the men and women who had served their country during World War II were finally home. Thousands lined Main Street and cheered the marchers. This view of Main Street was taken looking west to Asylum Street, across from the Old State House. The Corning building's most visible tenant was Liggett's drugstore. (Hartford Public Library, Hartford Times Collection No. 155.)

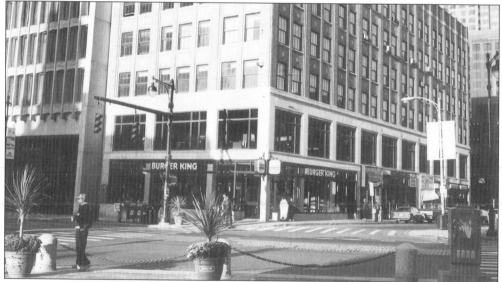

The Corning building, designed by Whiton and McMahon of Hartford, was built in 1929. Today, it is the oldest building on its block. This photograph shows the corner of Main and Asylum Streets as looked in the summer of 1999. Ruth Schaefer, the owner, had done a valiant job restoring the building and filling it with upscale tenants, including a New York Deli and a corporately owned Burger King. (Old State House.)

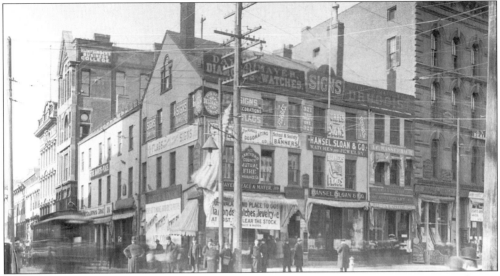

The Catlin building was an 18th-century structure that stood on the northwest corner of Main and Asylum Streets. Its exterior was upholstered with signs for everything from jewelry to signs and flags to insurance. In 1912, this building was replaced by the Aetna Realty building. The Aetna Realty building was razed in 1990 for the proposed Society for Savings building, which was never erected. Currently, the property serves as a parking lot and may one day be developed into a first-class hotel. (Connecticut State Library, Taylor Collection No. 8.)

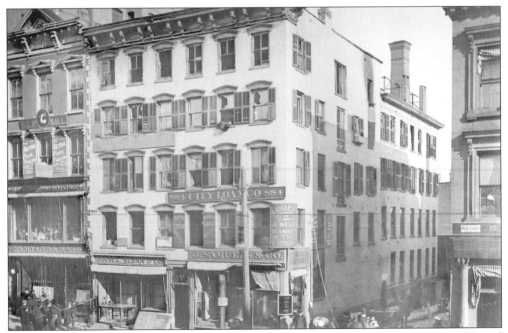

At 884 Main Street on the corner of Temple Street were the City Loan Company, Hansel Sloan and Company jewelers, and J. Samuels and Company shoe store. In 1906, a disastrous fire destroyed the building. Henry Kohn & Sons jewelers, at left, was not affected and remained in business at that 892 Main Street location for many years. (Connecticut State Library, Taylor Collection No. 132.)

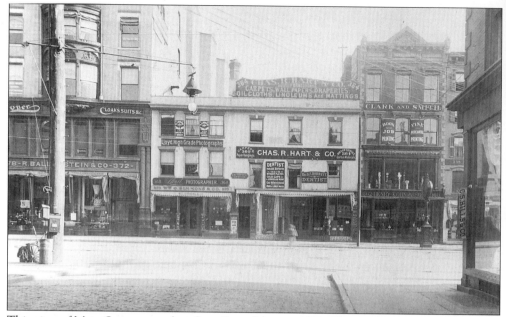

This view of Main Street was taken from Pratt Street c. 1890. The time must have been before 1898, when the city renumbered the street, as Henry Kohn & Sons is still at 362 Main Street. Shortly afterward, Charles. R. Hart & Company, to the left, expanded into a modern department store. (Connecticut State Library, Taylor Collection No. 104.)

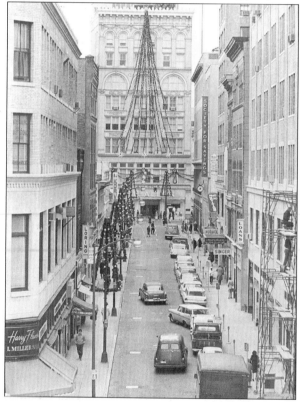

This view looking up Pratt Street to Main Street shows the extent of the Charles R. Hart & Company expansion. Designed by Isaac A. Allen, the new construction took place in 1898. The building later became the Sage-Allen department store, as shown in this 1964 photograph. (Hartford Public Library, Hartford Times Collection No. 211.)

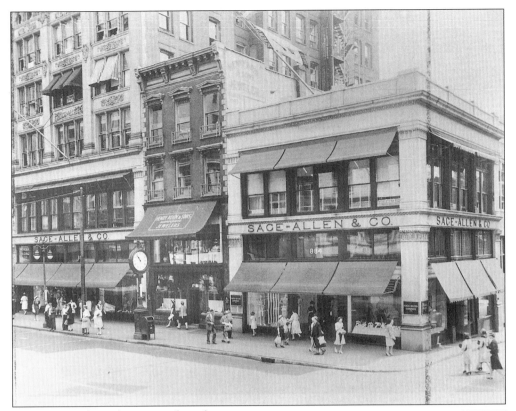

It is apparent from the cornice line that Sage-Allen is determined to acquire Henry Kohn & Sons jewelers and to absorb it into one unified façade. It finally happened when Kohn sold out, *c.* 1965. (Old State House.)

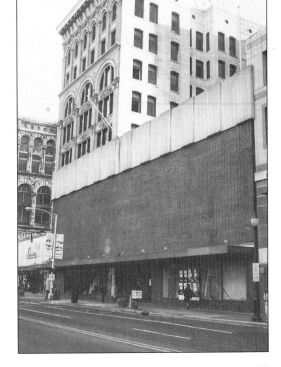

This 1999 photograph shows how Sage-Allen chose to unify the façade. The new front was put up in 1967. Sage-Allen as a store folded in the early 1990s, and there are now plans to restore the Charles R. Hart & Company façade. (Old State House.)

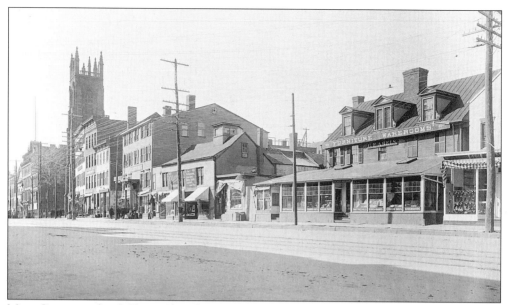

Main Street north of Christ Church Cathedral had commercial buildings and 18th-century houses that had become stores. On the right at 459 Main Street is G.F. Abels, which sold everything from sideboards, mattresses, and parlor suits to stoves. Ithiel Town designed Christ Church in 1828. It was designated the Cathedral of the Episcopal Diocese of Connecticut in 1919 at the urging of Bishop Chauncey B. Brewster. (Old State House.)

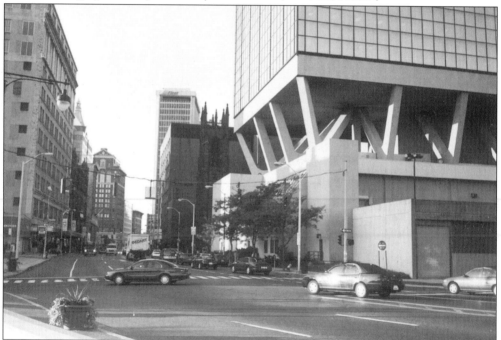

This is Main Street north of Christ Church Cathedral as it looked in the summer of 1999. The "Stilts Building" dominates the landscape. Irwin J. Hirsch & Associates designed it in 1981. Although the building is on the corner of Main and Church Streets, its address is One Corporate Center, which tends to confuse visitors. (Old State House.)

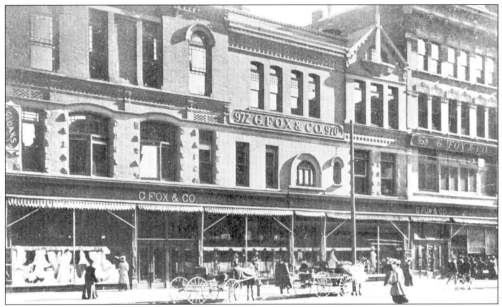

In 1847, Gerson Fox founded a department store in Hartford and named it G. Fox & Company. His son, Moses Fox, greatly expanded the business. Four separate buildings were joined by signs, as the store needed more room to better serve its customers. (Old State House.)

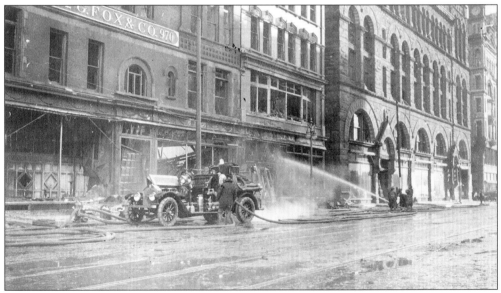

In 1917, G. Fox & Company was destroyed by fire. Even the billing department was destroyed, and so Fox's asked customers to pay as they remembered the balances owed. Remarkably, they did. (Old State House.)

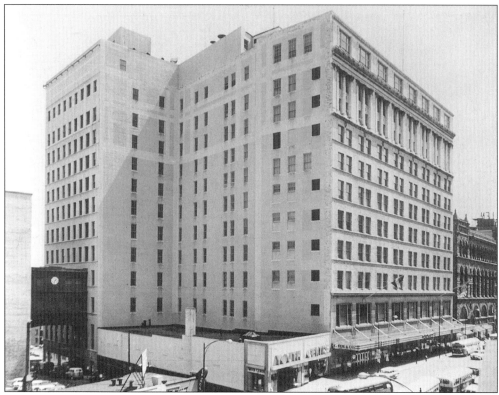

Cass Gilbert of New York designed the new G. Fox & Company store in 1918. Beatrice Fox Auerbach, granddaughter of the founder, modernized the store in 1934. She hired the Chicago firm of Taussig Flesch & Associates to remodel the store and give it a distinctive art deco marquee. This photograph, taken on April 29, 1957, shows the store with all of its additions and improvements. (Hartford Public Library, Hartford Times Collection No. 180.)

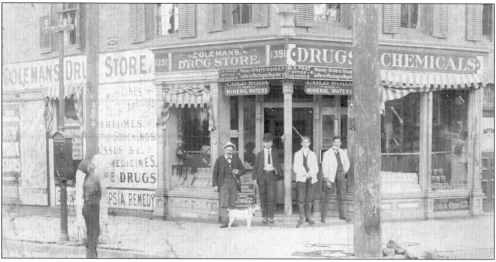

On the corner of High Street and Albany Avenue stood Coleman's Drug Store. Later it became Jeffers Pharmacy. Small businesses such as this one are essential to those who live and work in a city. (Old State House.)

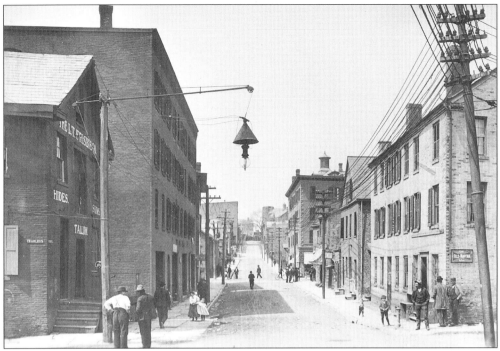

Looking west toward Main Street, Samuel Taylor took this photograph of the corner of Talcott Street west of Charles Street. Charles Street was a half block east of Front Street and ran north and south. It was named for Charles Weeks, who had a cooper (barrel) shop there in 1838. The street was eliminated in 1962 with the construction of Constitution Plaza. Front Street was renamed Columbus Boulevard. (Connecticut State Library, Taylor Collection No. 249.)

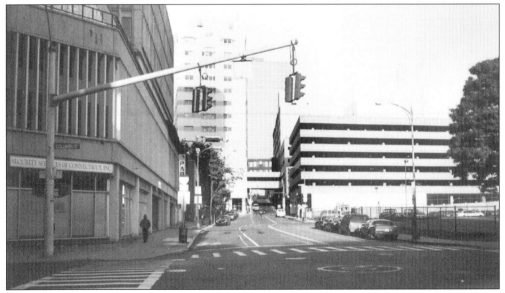

This is how Talcott Street west of Charles Street looked in the summer of 1999. Gone are all the houses and the shops. Only the grade of Talcott Street remains the same. Constitution Plaza is on the left. The G. Fox parking garage on Market Street is the large structure on the right. (Old State House.)

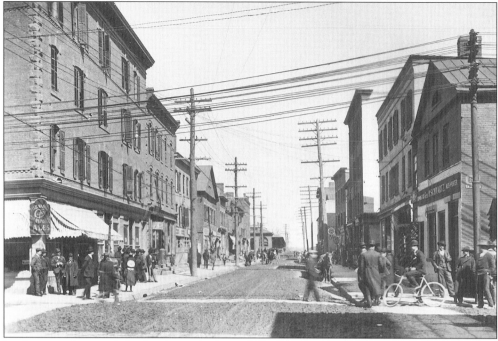

Looking north toward the freight yards, Samuel Taylor took this view of Front Street north of Talcott Street. Note all the shops and establishments that filled the area. (Connecticut State Library, Taylor Collection No. 247.)

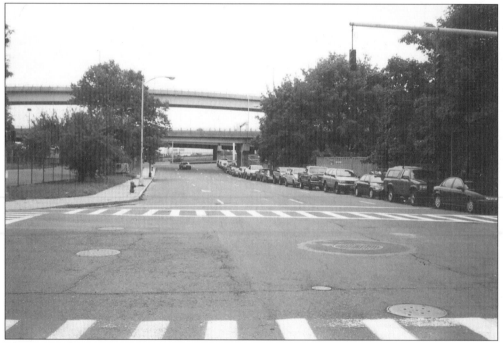

This view of Front Street, now Columbus Boulevard, north of Talcott Street was taken in the summer of 1999. Between urban renewal, Interstate 84, and the "flyover," everything has been eliminated. A city needs houses and businesses and people if it is to work. (Old State House.)

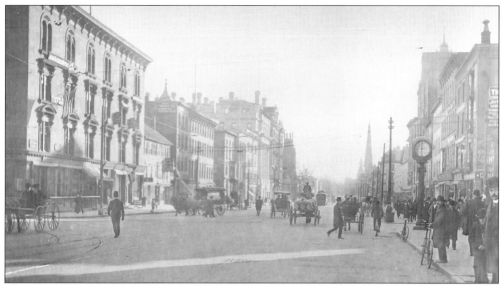

This photograph of Main Street at Pearl and Central Row looks southeast in 1905. The Hartford Trust Company is on the left corner. The church tower in the center is St. John's Episcopal Church, today the site of the Morgan Memorial of the Atheneum. (Connecticut State Library, Taylor Collection No. 130.)

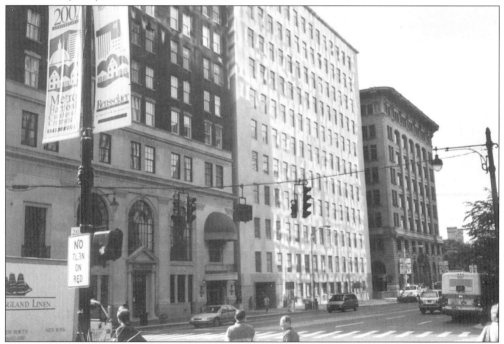

This view shows Main Street at Pearl Street and Central Row as it looked in the summer of 1999. Morris and O'Connor designed the Hartford Connecticut Trust Company building on the left corner in 1921. It is known today as 750 Main. To the south is the 1956 Travelers Building, which was designed by Voorhees Walker Smith and Smith of New York. Beyond it, the entrance to the Travelers and the towers of the Wadsworth Atheneum are visible. (Old State House.)

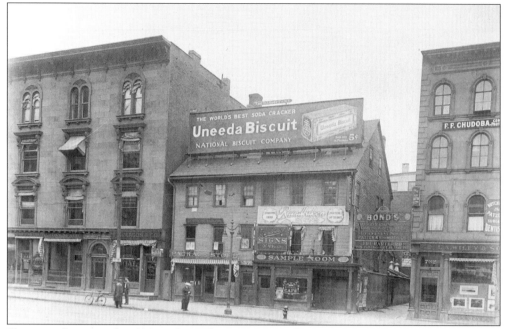

Shown is the east side of Main Street between Central Row on the left and Grove Street on the right. Grove Street once came to Main Street. The 18th-century building advertising Uneeda Biscuit was the Wyllys House. The Wyllys House and the building to the left were razed in 1956 so that the Travelers Insurance Company could expand. (Connecticut State Library, Taylor Collection No. 108.)

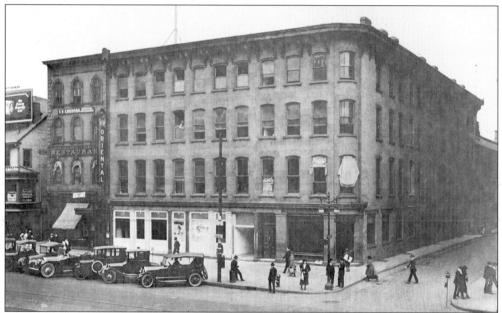

Just beyond the Wyllys House on Main Street were the Oriental Restaurant and the old Hartford Times Building. This picture was taken after 1920, when the Times moved into its new building on Prospect Street. Note that parking was allowed on Main Street in those days. (Connecticut State Library, Taylor Collection No. 109.)

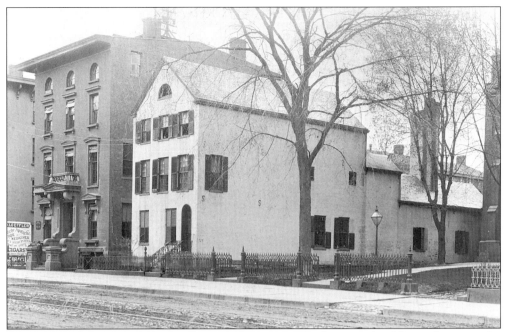

The white house is the Clark House on Main Street. It stood just south of Grove Street on the east side. The brick and brownstone building on the left is shown here in its original state. The railings to the right mark the entrance to the Universalist church from Main Street. (Aetna No. 487.)

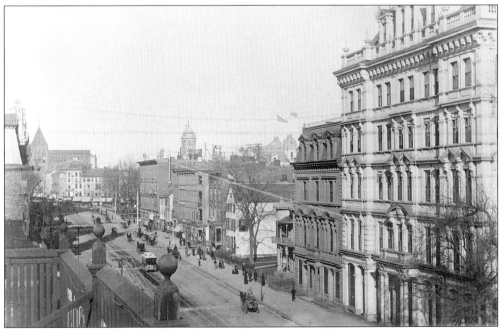

This view shows the east side of Main Street as it looked in 1889. The tower of the Richardson is on the far left. The great marble building on the right belonged to the Charter Oak Insurance Company. The brick and brownstone building next to the Clark House now has a new entrance and a new bay window. (Aetna No. 488.)

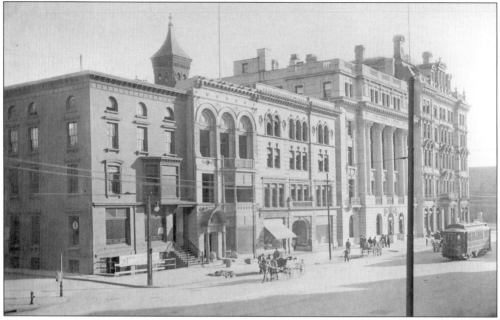

This *c.* 1900 view looks south on Main Street from Grove Street. The brick and brownstone building appears to have been further remodeled and coated to look all brownstone. The Clark House is gone, replaced by the Hartford City Gas Company's office building. The Universalist church remains, but it has built an office building on Main Street. (Connecticut State Library, Taylor Collection No. 129.)

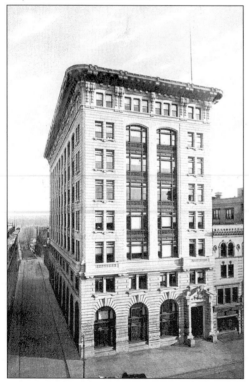

Donn Barber designed the Travelers Insurance Company building. In 1906, the company purchased the buildings on the corner of Main and Grove Streets, demolished the properties, and completed the first of the several construction phases for its new home office. The project took 12 years to complete. It is hard to imagine that the Main Street entrance was built in phases. (Old State House.)

On October 9, 1936, the German airship *Hindenburg* passed over Hartford. This view was taken beside the roof of the Travelers Insurance Company building, looking north to the Hartford National Bank building. (Old State House.)

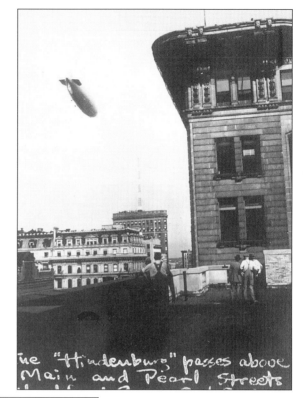

This view shows the Travelers Insurance company building as it looked when finished in 1918. Note the minaret-shaped tower topped with gold orbs. In 1938, the Travelers Insurance Company redesigned the tower into a squatter version. In 1998, the company removed the gold orbs as a cost-saving measure. What will be next? (Old State House.)

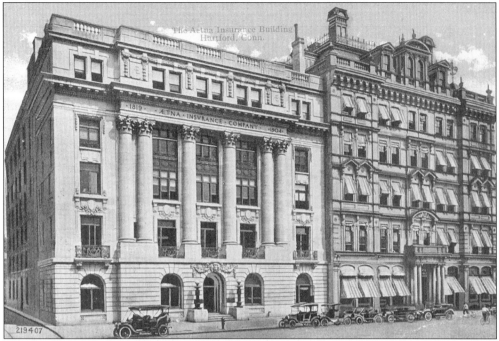

Just south of the Travelers Insurance Company building, on Main Street, was the 1904 Aetna Insurance Company, known locally at "Little Aetna." To the right of it is the Charter Oak Insurance building. (Old State House.)

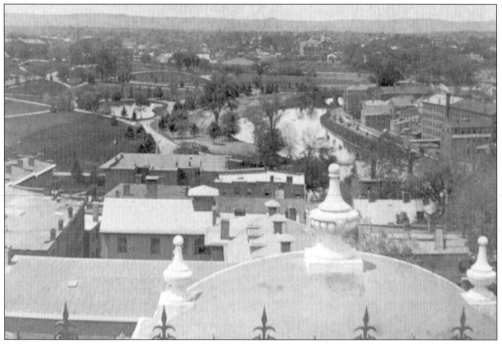

This extremely rare view was taken in 1865 from the roof of the Charter Oak Insurance Company, looking west toward Bushnell Park. The Park River flowed through the park and the buildings of Trinity College are on the hill. (Old State House.)

In 1895, the Aetna Life Insurance Company bought the Charter Oak Insurance Company building on Main Street, changing the name over the door and adding four additional floors. (Aetna No. 385.)

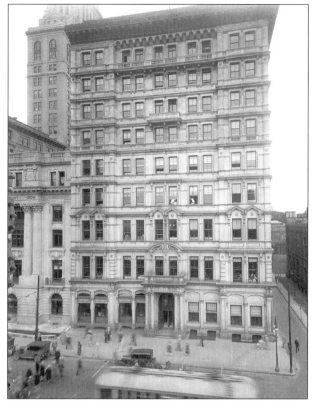

Daniel Wadsworth founded the Wadsworth Atheneum in 1842. It is the oldest continually operated public art museum in the nation, and what a treasure it is. This is the original building as it looked c. 1890. Later, the city dropped the street some 8 feet, drastically changing the relationship of the building to sidewalk pedestrians. See page 50 for the 1999 view. (Connecticut State Library, Taylor Collection No. 111.)

Henry C. Robinson, mayor of Hartford and a principal in the law firm of Robinson & Cole, lived in this house on Main Street where the Federal Building is today. He was asked by Pres. Grover Cleveland to become ambassador to Mexico. He declined the honor, saying, "What? And leave Hartford?" (Connecticut State Library, Taylor Collection No. 134.)

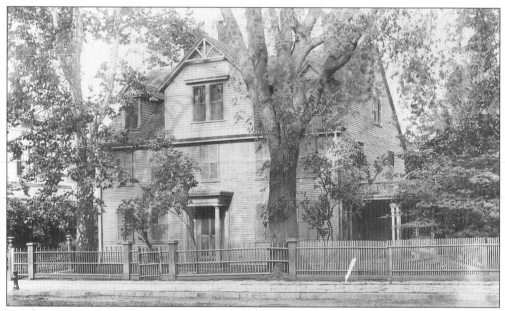

The John Butler House on Main Street is the oldest house in the city; parts of it date to 1740. In more recent times, the house was owned and enlarged by the McCook family. Known today as the Butler-McCook Homestead, the house is open to the public under the auspices of the Antiquarian & Landmarks Society. (Connecticut Library, Taylor Collection No. 115.)

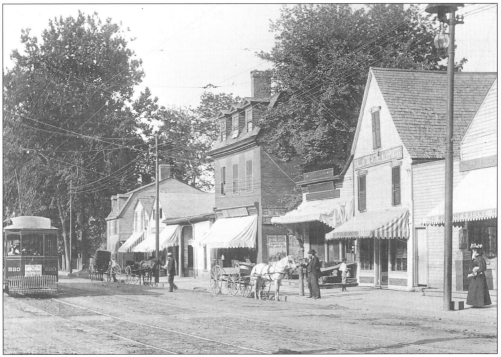

This is the block to the south of the Butler-McCook Homestead on Main Street as it looked on July 18, 1896. The trolley advertises a picnic at Union Grove. (Aetna No. 501.)

This is the same block on Main Street as it appeared in the summer of 1999. Charter Oak Avenue is on the right. Urban renewal in the 1950s and 1960s razed all of the buildings. (Old State House.)

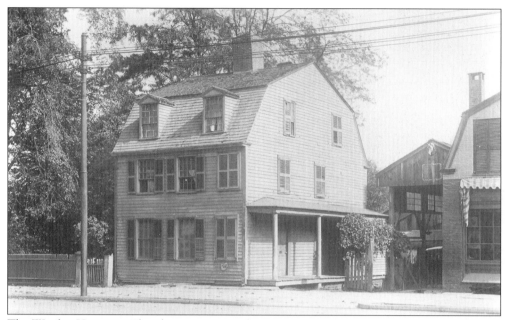

The Wooley House, or Thatcher House, stood on Main Street, just to the south of the Butler-McCook Homestead. (Connecticut State Library, Taylor Collection No. 116.)

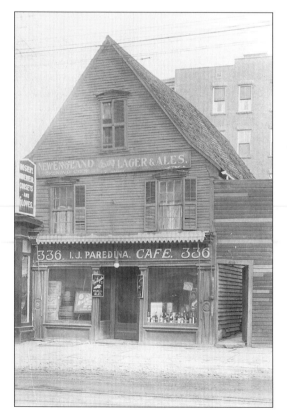

This alehouse also appears in the 1896 photograph on page 93. There, at 98 Main Street, it was painted white. In 1898, the alehouse was renumbered 336 Main Street; it was painted a dark color and was listed as the Joseph Whiting House, still serving ale. (Connecticut State Library, Taylor Collection No. 118.)

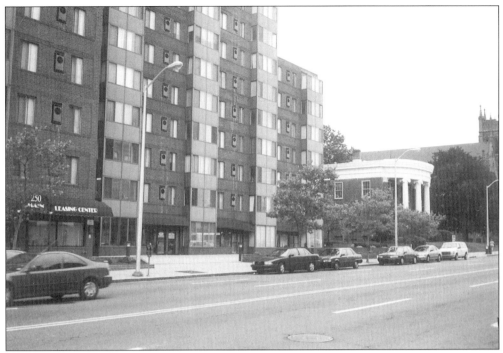

This view of Main Street was taken looking south from the corner of Charter Oak Avenue in the summer of 1999. The only residence that remains is Ellery Hill's, with its great white portico. (Connecticut State Library, Taylor Collection No. 118.)

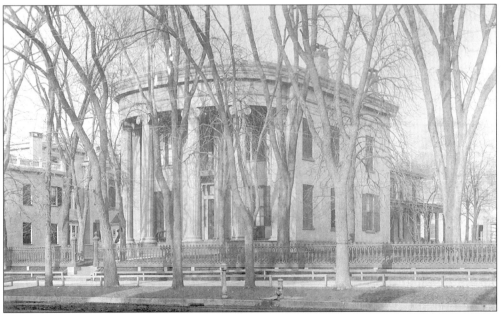

This house was built in 1840 for Ellery Hills. Later, it became the home of Ira Peck and then the rectory for St. Peter's Church. Today, it has been converted into law offices. (Connecticut State Library, Taylor Collection No. 123.)

To the north of the Hills House stood the Harry Redfield House, above, and the Samuel Woodruff House, below. Both were demolished for the apartment building. Today, with all the high office buildings, it is hard to imagine Main Street as a gentle, broad boulevard with stately homes. (Connecticut State Library, Taylor Collection, No. 119, No. 122.)

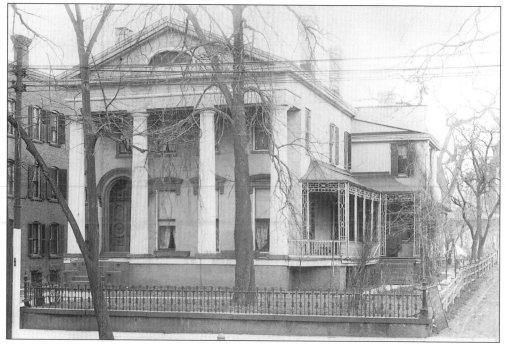

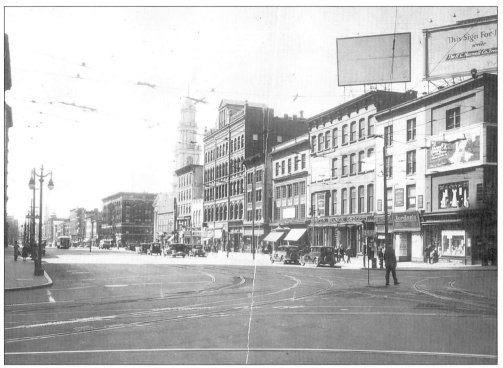

This view shows Main Street at the corner of Pearl Street on March 30, 1938. In the center, the spire of Center Church rises. (D'Apice, Old State House.)

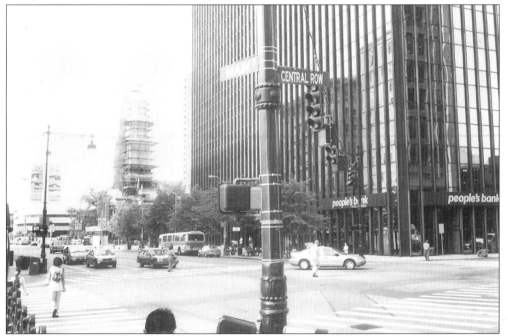

This is the corner of Main Street at Pearl as it looked in the summer of 1999. The "Gold Building" now occupies the corner. To the south, Center Church is encased in scaffolding for a major restoration. (Old State House.)

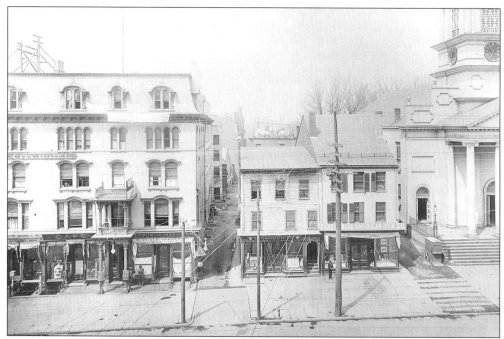

This view shows Main Street in May 1897. On the left is Center Church, then painted a creamy white color. To the left of the church are two 18th-century dwellings, the narrow alley of Gold Street, and the City Hotel. (Aetna No. 484.)

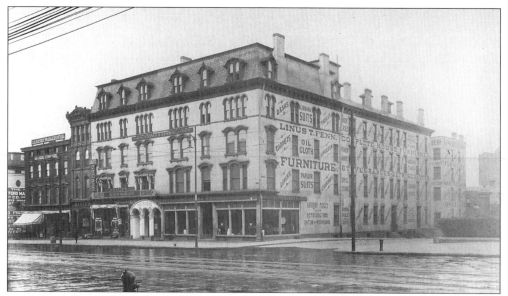

In 1900, Emily Seymour Holcombe led the drive to clean up and widen Gold Street by removing many buildings and to restore the Ancient Burying Ground. This view shows Gold Street after the cleanup. The City Hotel, built in 1819, has become Linus T. Fenn's furniture store. (Connecticut State Library, Taylor Collection No. 14.)

Gold Street was a narrow city alley that was home to boarding stables and carpenter shops. (Connecticut State Library, Taylor Collection No. 357.)

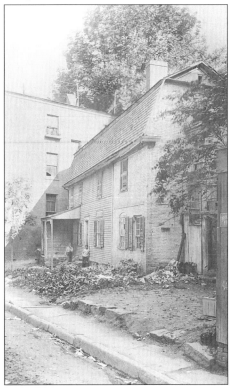

On Gold Street, behind Nichols & Humphrey's store was this early house. The sign on the front reads, "Laundry." All of the houses and stables were removed in the cleanup and widening of the street in 1900. (Connecticut State Library, Taylor Collection No. 358.)

On the corner of Main and Mulberry Streets stood the Hartford Market. The entire block was demolished in 1964 to make room for Bushnell Plaza and the new MDC building. Mulberry Street no longer exists. (Connecticut State Library, Taylor Collection No. 17.)

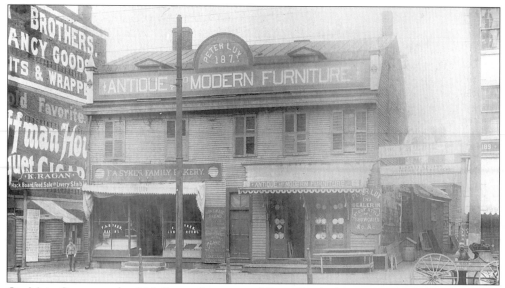

On Main Street south of Mulberry Street stood Peter Lux's Antique and Modern Furniture store. The Sykes family ran a bakery and lunchroom in the left part of the building. (Connecticut State Library, Taylor Collection No. 15.)

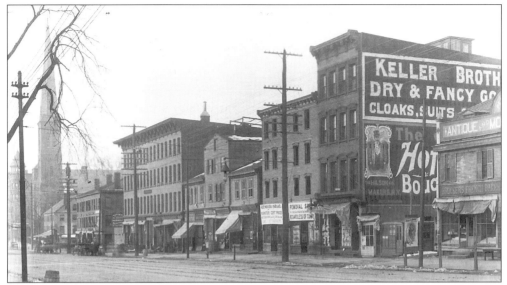

This view of the block on Main Street south of Mulberry Street looks toward the steeple of the South Baptist Church. The church was built in 1854, and its steeple was 226 feet high. (Connecticut State Library, Taylor Collection No. 18.)

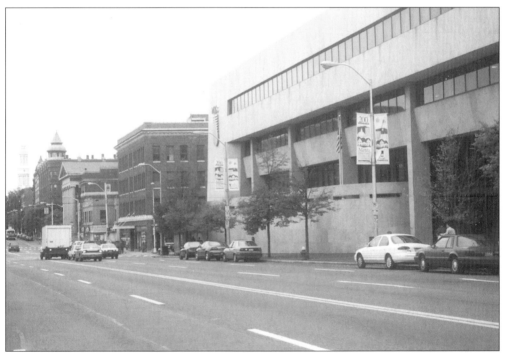

The same block on Main Street south of Mulberry looked this way in the summer of 1999. The joining of the First Baptist and South Baptist congregations called for a new church building and a new name: Central Baptist Church. Isaac A. Allen Jr. of Hartford designed the new church in 1926. The MDC headquarters is the wall of marble on the right. It is hard to make a city a livable place when all of its buildings are designed as impenetrable fortresses. (Old State House.)

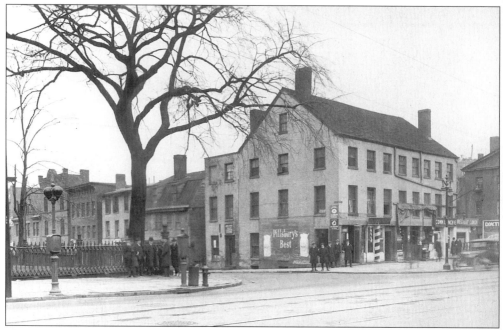

This view of the northwest corner of Main Street at Elm Street was taken c. 1900. The 18th-century building on the right housed a barbershop and the Connecticut Lunch. The cast-iron fence on the left marked the churchyard of the Second Baptist Church. (Connecticut State Library, Taylor Collection No. 33.)

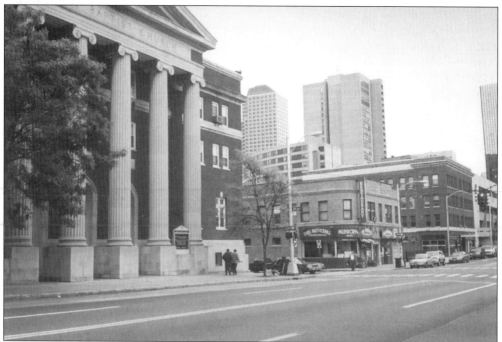

Shown is the corner of Main Street at Elm Street in the summer of 1999. The new Central Baptist Church is on the left. The Municipal Restaurant replaced the Connecticut Lunch in 1924, with a building designed by Berenson and Moses of Hartford. (Old State House.)

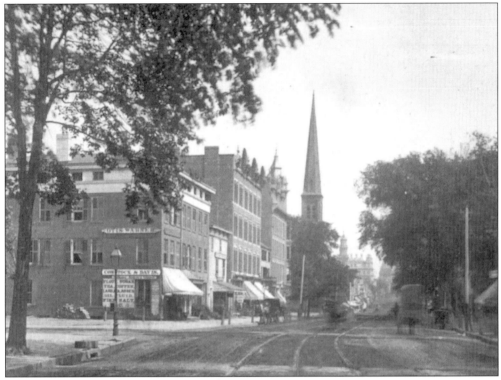

This view of Main Street looks north from the corner of Buckingham Street c. 1880. The steeple of the Second Baptist Church is in the background. Also visible are the 1875 Hotel Capitol building, the 1875 McKone building, and the Comstock & Davis building on the corner. Comstock & Davis advertised on the side some of the products it had to offer: flour, sugar, tea, coffee, lard, molasses, oil, fish, and salt. (Old State House.)

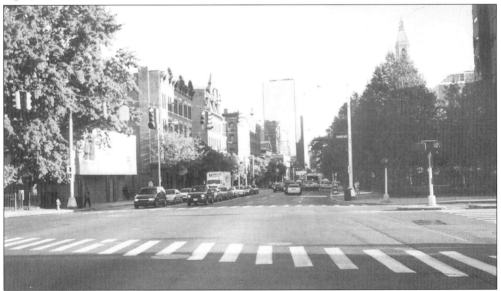

This is how Main Street at the corner of Buckingham Street looked in the summer of 1999. The Gold Building and the Travelers Tower dominate the skyline. (Old State House.)

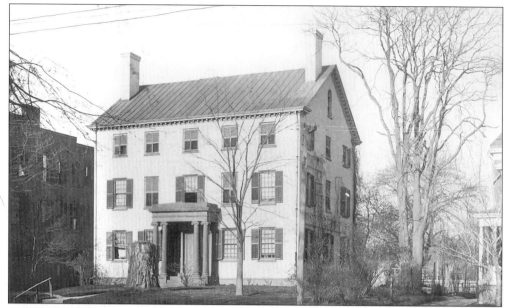

At 118 Main Street stands the Henry Barnard House. Built in 1807, it was the birthplace and home of Henry Barnard, the first U.S. commissioner of education, for whom Barnard College is named. Barnard believed that all schools should "be good enough for the richest and affordable by the poorest." (Connecticut State Library, Taylor Collection No. 124.)

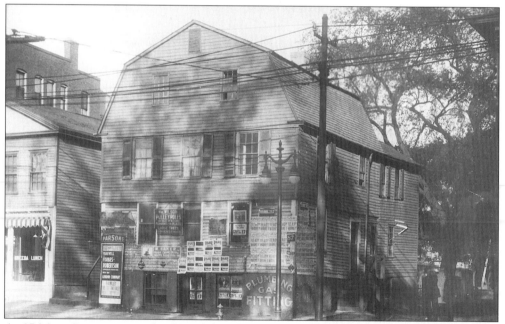

At 87 Main Street, just south of South Congregational Church, stood this early 18th-century house. The house appears to be abandoned: it is missing some windows and its exterior has been neglected. Next-door to the left was Uneeda Lunch. (Connecticut State Library, Taylor Collection No. 21.)

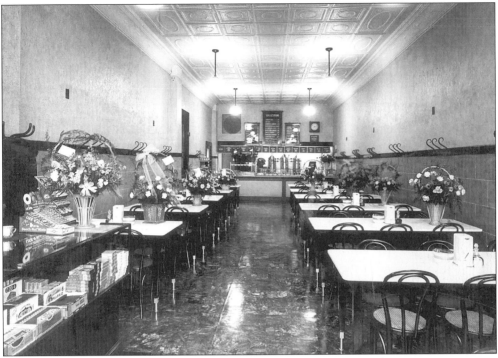

Uneeda Lunch was a popular lunch spot on South Main Street. Pictured is a rare interior view of the lunchroom, taken *c.* 1920. The flowers are fresh and fragrant, the floor is clean and shiny, and the urns are all polished. Menu suggestions included chicken soup for 15¢, creamed beef on toast for 35¢, and calves liver and bacon for 45¢. (Bryant Miller.)

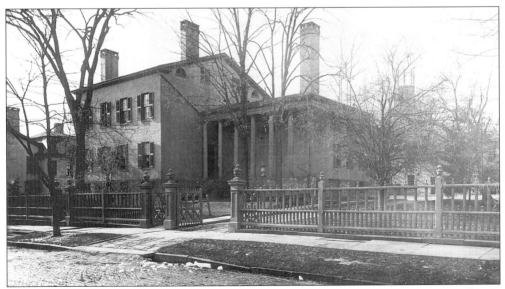

Prospect Street was once home to some of Hartford's greatest mansions. The home of A.C. Dunham stood where Burr Mall is today. In addition to the main house, the Dunham property included an extensive series of gardens, stables, and outbuildings. (Connecticut State Library, Taylor Collection No. 153.)

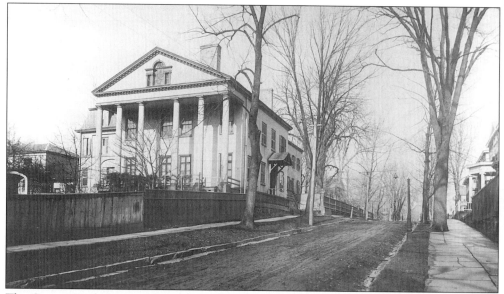

The George Bartholomew Mansion stood at the crest of Prospect Street, looking south to the Park River. On July 4, 1918, a bridge over the river was opened. The bridge changed Prospect Street from a quiet dead-end neighborhood street, which stopped at Arch Street, into a busy two-lane crosstown thoroughfare. (Connecticut State Library, Taylor Collection No. 154.)

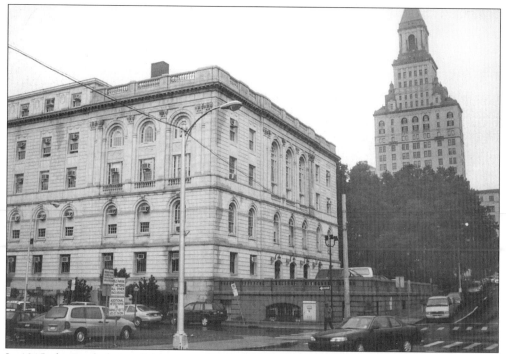

In 1915, the Bartholomew Mansion was torn down and the new City Hall was built in its place. Davis and Brooks of Hartford carefully designed it to complement the Morgan Memorial of the Wadsworth Atheneum. This is how the Prospect Street side of City Hall looked in the summer of 1999. (Old State House.)

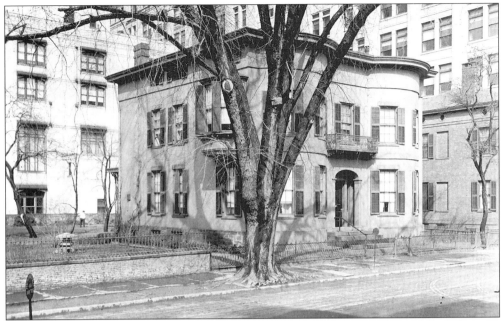

The George Perkins House stood on 53 Prospect Street, on the west side between Atheneum Square North and Central Row. In the background are the Hungerford House and the looming office buildings of the Travelers Insurance Company. (Connecticut State Library, Taylor Collection No. 149.)

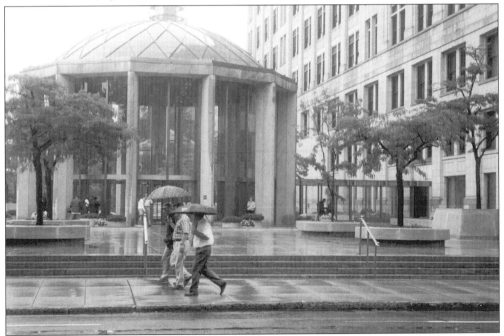

In 1962, the Travelers Insurance Company purchased the Perkins and Hungerford Houses, the accompanying Wadsworth stable, and the old Aetna building on Main Street and tore them all down. In their place this plaza—designed by Voorhees, Walker, Smith, Smith and Haines of New York—was built with a new domed main entrance to the Travelers. (Old State House.)

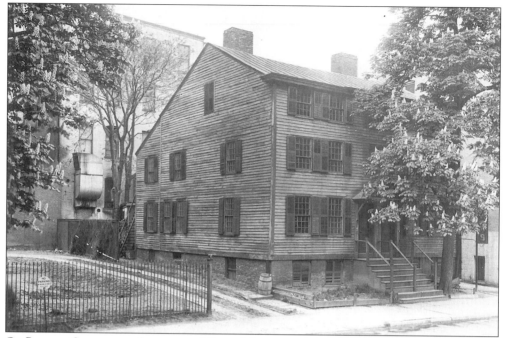

On Prospect Street, near the corner of Central Row, stood the home of Dr. Roderick Morrison. The 18th-century dwelling had wonderful 12-over-12 windows on the first floor and 12-over-8 windows on the second floor. Note the flowering chestnut tree beside the house. (Connecticut State Library, Taylor Collection No. 140.)

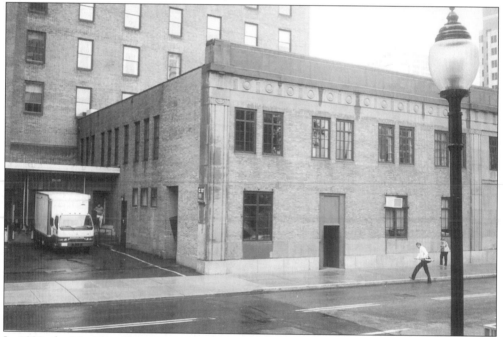

In 1938, the Morrison House was torn down and replaced by the Smith and Bassette addition to the 1927 Travelers Insurance Company building on Central Row. This is the side view of that building, on Prospect Street, the former site of the Morrison House. (Old State House.)

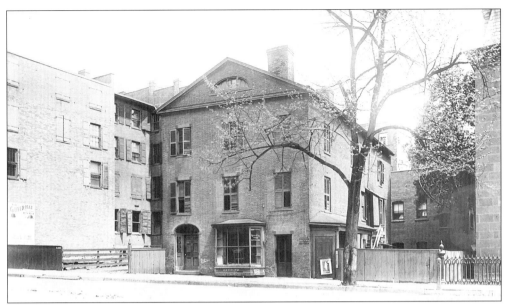

The Corning House stood at 150 Trumbull Street, on the east side, between Asylum and Pearl Streets. The building to the right is the Hall of Records. (Connecticut State Library, Taylor Collection No. 177.)

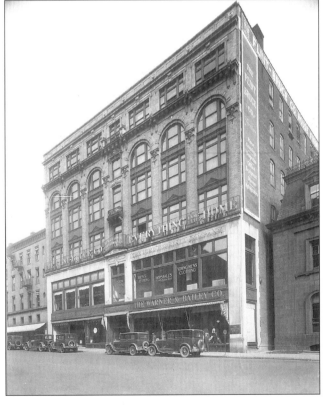

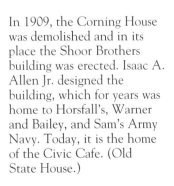

In 1909, the Corning House was demolished and in its place the Shoor Brothers building was erected. Isaac A. Allen Jr. designed the building, which for years was home to Horsfall's, Warner and Bailey, and Sam's Army Navy. Today, it is the home of the Civic Cafe. (Old State House.)

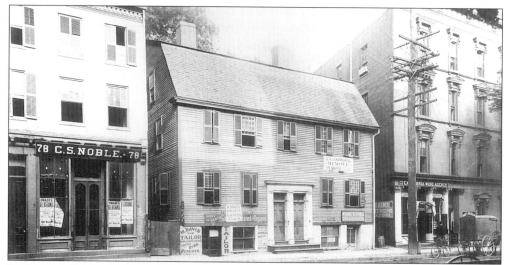

Dr. Norman Morrison lived at 76 Trumbull Street. The 18th-century house was later converted into a two-family home and then was used for commercial interests. This photograph was taken in 1896, just before the building was demolished. Of special note is the 1861 brownstone building to the right, with its flashy entrance to the California Wine Agency. (Connecticut State Library, Taylor Collection No. 179.)

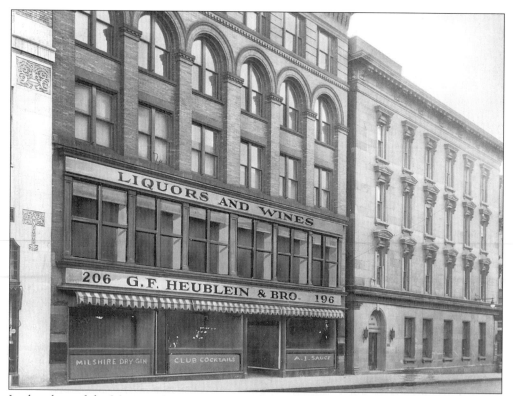

In the place of the Morrison House, G.F. Heublein & Brothers erected this building in 1896. Note how the former wine agency entrance in the brownstone building to the right has been reworked for the Charter Oak Bank. (Hartford Public Library, Hartford Collection)

110

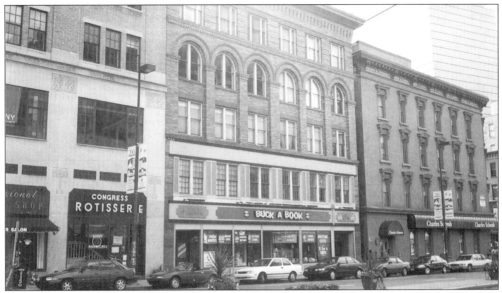

This is the same block on Trumbull Street between Pratt and Asylum as it looked in the summer of 1999. Buck A Book is on the ground floor of the Heublein building. On the left, in the 1928 Steiger Building, is Congress Rotissere, which has been replaced by Max Bibo's. (Old State House.)

This view of Asylum Street at the corner of Trumbull Street was taken in 1890, looking west toward the railroad station. Note that Asylum Street was a two-way street at the time. (Old State House.)

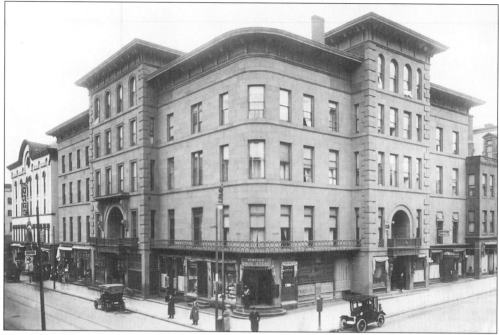

The Allyn House Hotel stood at the northwest corner of Trumbull and Asylum Streets. In its day, the Allyn House was the city's most fashionable hotel. It was torn down in the 1960s. The white building on the left was the Hartford Auditorium. It was destroyed by fire on February 26, 1914. (Connecticut State Library, Taylor Collection No. 167.)

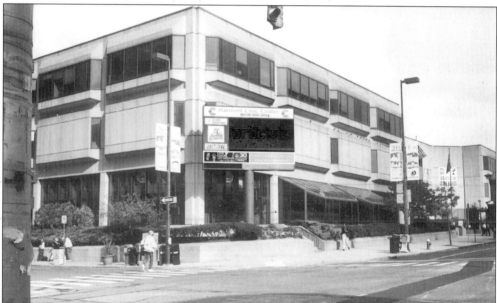

This view of the Allyn House corner on Trumbull Street shows it as the site of the Hartford Civic Center in the summer of 1999. Designed by Vincent G. King of Philadelphia, the Civic Center opened in 1975. Expected to revitalize the city, it has not worked. Today, most of the stores are empty and plans are being made to demolish at least part if not all of the complex. (Old State House.)

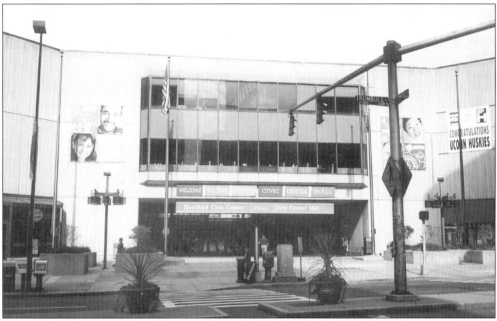

This is the main entrance to the Hartford Civic Center as it appeared in the summer of 1999. The setback design makes it look like the entrance to a parking garage rather than the front of a mall or a civic center. (Old State House.)

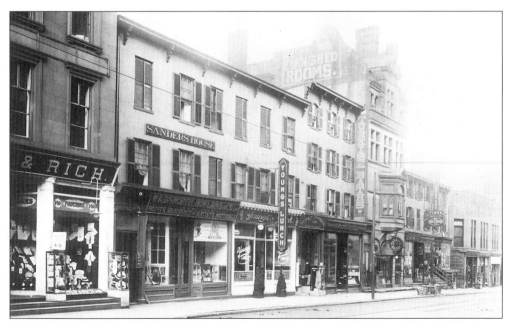

The great financier J.P. Morgan was born on April 17, 1837, at the home of his grandparents, Joseph and Sarah Morgan. The grandparents lived on the south side of Asylum Street between Trumbull and Haynes Streets. In this *c.* 1890 view, the Morgan House is the one labeled Sanders House, at 159 Asylum Street, also the address for Wadsworth Howland & Company and Youngs Lunch. CitiPlace occupies this site today. (Connecticut State Library, Taylor Collection No. 168.)

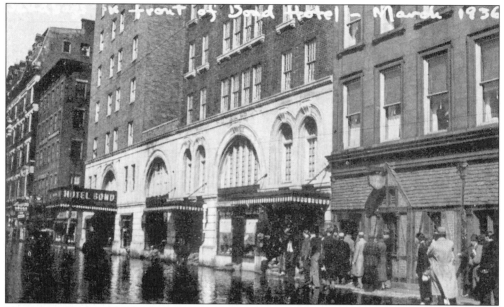

The Hotel Bond was built in 1913 at 318 Asylum Street. Russell F. Barker of Hartford designed it. This view is of the rising waters from the flood of 1936, with sandbags set up to keep the water out of the lobby. (Old State House.)

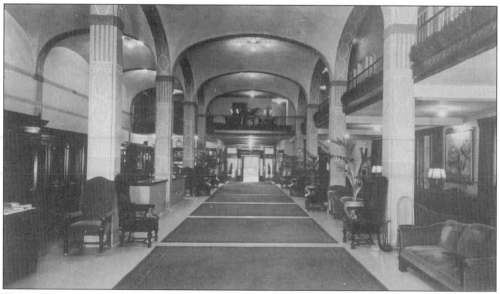

Shown is the main lobby of the Hotel Bond. Today, it is the home of the Sport Sciences Academy; however, plans to convert the building into luxury apartments are under consideration. (Old State House.)

Just west of Union Station, Asylum Street climbs sharply, as seen in this 1959 photograph. Note all the shops along the street on the right and the splendid Victorian house in the center. (Hartford Public Library, Hartford Times Collection No. 103.)

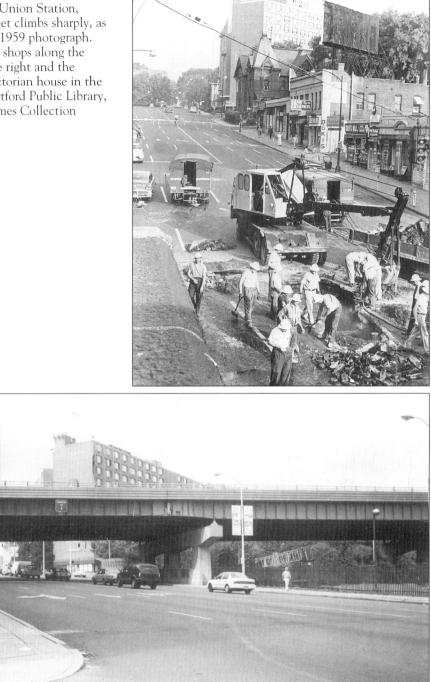

This is the same area of Asylum Street in the summer of 1999. Everything except the Capitol View apartment building was demolished to make room for the highway. (Old State House.)

Where Farmington Avenue and Asylum Street part, there is a triangular slice of land. Originally, it was the site of the Henry K. Morgan House, which was later owned by Thomas Day. In 1928, following the death of Mrs. Day, the house was demolished and Broad Street was extended between Farmington and Asylum Streets. (Connecticut State Library, Taylor Collection No. 191.)

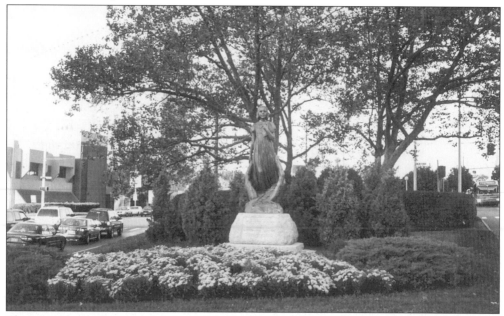

This view shows the Day triangle as it looked in the summer of 1999. On the site is Frances Wadsworth's statue of Alice Cogswell, commemorating the founding of the American School for the Deaf in 1817. The statue was unveiled on April 15, 1953. Originally called the Asylum for the Deaf, the school was once located where the Hartford Insurance buildings are today. Asylum Street was named in the school's honor. (Old State House.)

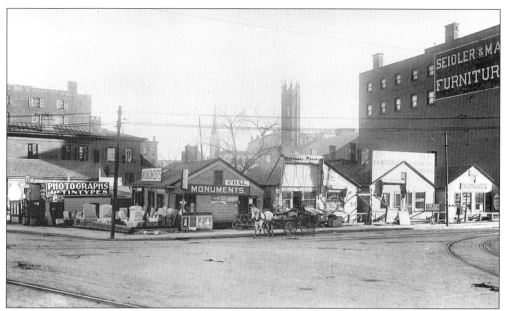

At the corner of Ford and Pearl Streets *c.* 1888, a photographer advertised tintypes, Patrick Dunn ran a monument business on the corner, and Seidler & May had the large furniture store at 306–318 Pearl Street. (Connecticut State Library, Taylor Collection No. 163.)

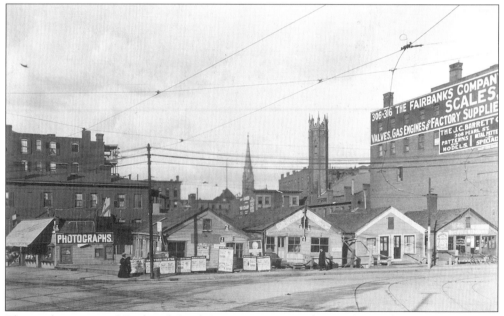

This is the corner of Ford and Pearl Streets some years later. The Fairbanks Company has replaced the furniture store at 306–316 Pearl Street, and the photographer has trimmed tintypes from his sign. (Connecticut State Library, Taylor Collection No. 161.)

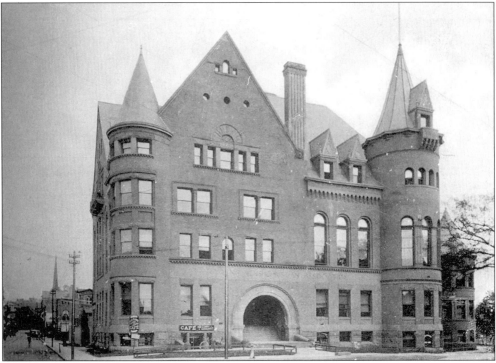

The YMCA building on the south corner of Ford and Pearl Streets was designed by Edward Hapgood in 1873 and was demolished on April 6, 1974. Visible just behind it is the African Methodist Episcopal Church on the corner of Ann and Pearl Streets. Farther down Pearl Street, near Main Street, is the 212-foot steeple of the 1851 Pearl Street Church. (Old State House.)

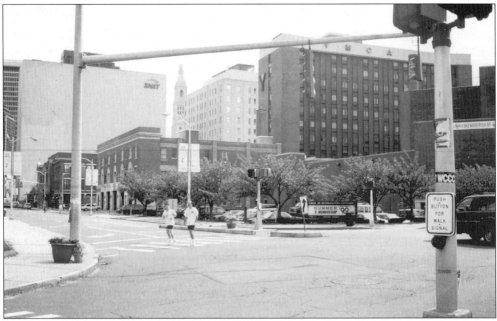

This view shows the same corner of Ford and Pearl Streets in the summer of 1999. The YMCA was razed for a parking lot. (Old State House.)

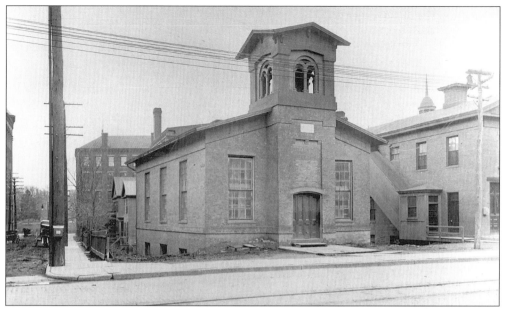

The African Methodist Episcopal Church was built on the corner of Pearl and Ann Streets in 1857. (Connecticut State Library, Taylor Collection No. 164.)

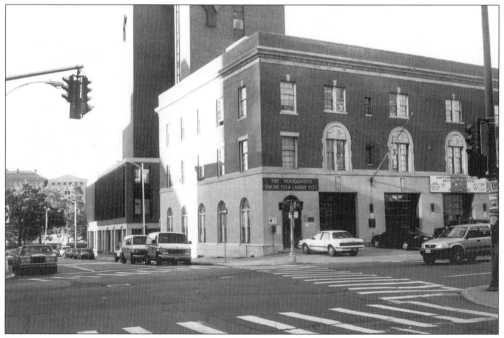

This is the same corner of Pearl and Ann Streets in the summer of 1999. The church was replaced in 1926 by the Hartford Fire Department building. Smith and Bassette of Hartford designed it. (Old State House.)

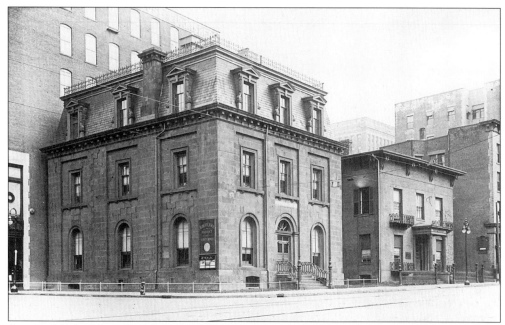

On the northeast corner of Pearl and Trumbull Streets stood the Hall of Records building. Behind it, on Trumbull Street, was the Corning House (see p. 109). Later, the Hall of Records building became the office for R.C. Knox. Apparently, the Corning estate owned the land; for in 1935, the estate erected a new building, designed by Lester B. Scheide of Hartford, at 100 Pearl Street. (Connecticut State Library, Taylor Collection No. 192.)

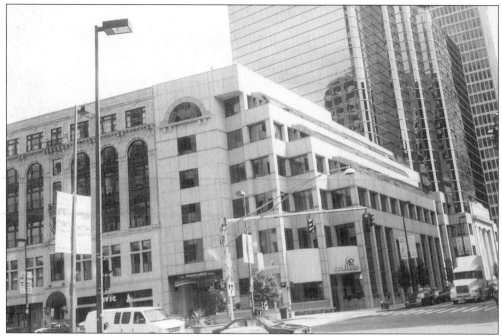

The Scheide building was razed in 1982 and replaced by this structure built for Bank Boston. This photograph was taken in the summer of 1999. Today, Bank Boston is part of Fleet Bank and the corner now bears the Sovereign Bank logo. (Old State House.)

Behind the old plant of Case, Lockwood, and Brainard Printers on the southwest corner of Pearl Street at Trumbull Street was this series of buildings. The tall wing on the left, with its 8-over-12 windows, was said to be part of the Meeting House–Court House that stood on the site of the Old State House from 1720 to 1783. The site is now occupied by the SNET building. (Connecticut State Library, Taylor Collection No. 162.)

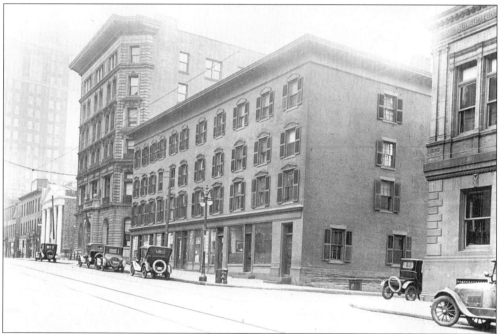

This view of Pearl Street looks east to Main Street. On the right is a corner of the National Fire Insurance Company's 1893 home office, which was designed by W.C. Brocklesby. The company moved in 1941 to 1000 Asylum Street. The street to the left of the National Fire building is Lewis Street. (Connecticut State Library, Taylor Collection No. 193.)

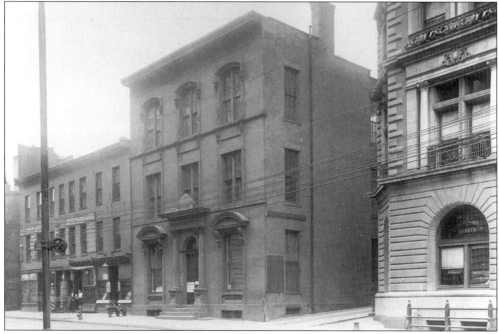

The State Savings Bank on the south side of Pearl Street had a beehive over the door, symbolic of the productive bank and all that it would do with your savings. This 1860 façade was modernized with white colonial columns before it was demolished to make room for the Gold Building. (Connecticut State Library, Taylor Collection No. 160.)

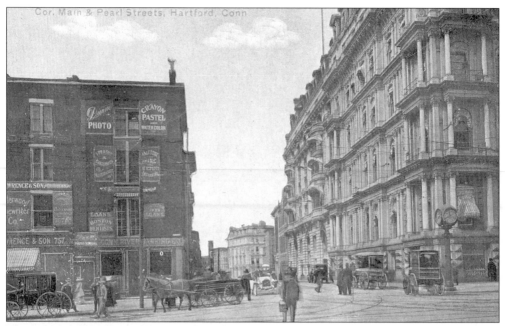

This view of the corner of Main and Pearl Streets looks west on Pearl Street. The Pearl Street church has been razed and Hartford National Bank has expanded on the site. At the end of Pearl Street, at Trumbull Street, is the old Hartford Insurance building. (Old State House.)

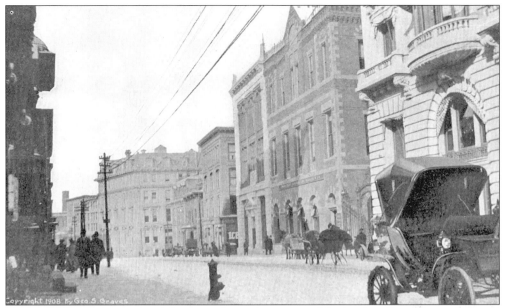

Shown in this 1908 view, Bank Lane was located just west of the bank on Pearl Street, followed by the Connecticut General Life Insurance building. It was a very high-style Victorian edifice, with striped arches and a formal entrance. (Old State House.)

In 1950, the Connecticut General Life Insurance building was modernized. Its exterior was coated to look fresh and new, and the ground floor at 56 Pearl Street became the home of Harvery & Lewis Opticians. The gates to Bank Lane can be seen to the right of the building. When the new Hartford National home office was built, the Connecticut General building was razed and Bank Lane was relocated in its place. (Stewart Lewis.)

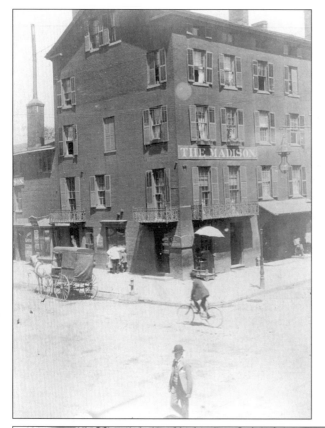

The Madison stood on the corner of Trumbull and Pratt Streets. There is no record of the hotel or its dates. Its location is known because the street names are on the corner of the building. (Old State House.)

This view shows the corner of Trumbull and Pratt Streets in the summer of 1999. In 1926, the Standard building replaced the Madison. Buck and Sheldon of Hartford designed the Standard, which was enlarged in 1988 by adding four floors. (Old State House.)

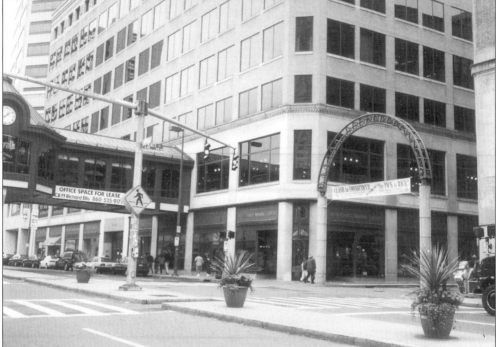

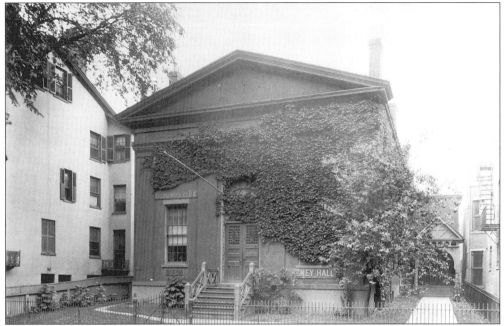

Pratt Street ran through the John Pratt farm. In 1814, the Pratts conveyed the land to the city but only for use as a road "and for no other purpose." At 40 Pratt Street on the north side was the Goodwill Club and Keney Hall. They were razed to make way for the Standard building. (Connecticut State Library, Taylor Collection No. 182.)

This photograph was taken from the window of 68 Pratt Street, looking east to Main Street in 1899. In the distance is the Worth building, with the clock, and to the right the Hart or Sage-Allen building. Visible in the right corner is part of the Society for Savings building, before it was remodeled. (Snow, Old State House.)

The Stephen Spencer House was built at 80 Pratt Street in 1830. By the late 1920s, the house was being used as a commercial building for the Goldenblum Millinery Company and as Ye Olde Windmill tearoom. (Old State House.)

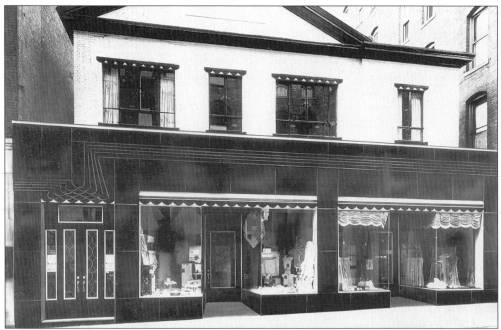

In 1937, architect Lester B. Scheide modernized the building for the Goldenblum Millinery Company. The cost of the new Pittsburgh Plate Glass specified products was $1,750. The store noted a "200% increased volume in sales." (Old State House.)

This is how 80 Pratt Street looked in 1999. The building is actually a replica of the original Spencer House; the architects followed the details and the scale of the original house. Today, it is the restaurant called No Fish Today. (Old State House.)

The Unity Building on Pratt Street was built in 1891 for the Unitarian Church. In 1928, it was remodeled and received the Jacobean revival first-floor front. Today, Lux Bond & Green Jewelers, founded in 1898, has its Hartford store on the main floor, as seen here in 1999. (Old State House.)

The new Founders Bridge Promenade was dedicated on September 3, 1999. In the railings are the original medallions from the former Charter Oak Bridge. The medallions each represented different series of icons, two for Hartford (the Charter Oak and the Old State House), and two for East Hartford (the Congregational church and the aircraft industry). This medallion is the one that shows the Old State House. Having the oldest public building on the newest public bridge is more than appropriate. (Old State House.)

In 1997, Riverfront Recapture was presented the Waterfront Center's highest award for excellence. In presenting the award, the jurors wrote:

> Cities everywhere should take heart, because Riverfront Recapture is demonstrating that bold undertakings can be accomplished, provided the vision and the will is there.

Hartford has the vision and the will, and the next years could be the best this city has ever enjoyed. Anyone interested may send along old pictures, so that more memories and stories can be saved and shared.

Wilson H. Faude
Executive Director
Old State House
800 Main Street
Hartford, Connecticut 06103